# LANDFALL 242

November 2021

Editor Lynley Edmeades
*Reviews Editor* Michelle Elvy

Founding Editor Charles Brasch (1909–1973)

*Cover:* Conor Clarke, *University Oval Cricket Field (as described by Mark Flowerday)*, 2020, C-print with braille (PVC, UV ink), 980 x 790mm

*Published with the assistance of Creative New Zealand.*

OTAGO UNIVERSITY PRESS

CONTENTS

- 4 Kathleen Grattan Award for Poetry 2021 Judge's Report, *David Eggleton*
- 6 Landfall Essay Competition 2021 Judge's Report, *Emma Neale*
- 10 The New Man, *Andrew Dean*
- 20 Small Shaft of Sun: Skylla tells the story of her favourite, *Vana Manasiadis*
- 22 What extremely muscular horses can teach us about climate change, *Frankie McMillan*
- 23 A Wise Man, *Bree Huntley*
- 26 Gratitude, *Derek Schulz*
- 27 As if held (fullness), *Robyn Maree Pickens*
- 28 Ihi Wehi Wana, *Airana Ngarewa*
- 31 The Wacky Waving Inflatable Tube Man, *Rebecca Nash*
- 33 Church Picnic, *Nicola Thorstensen*
- 34 Southend Special, *Scott Menzies*
- 40 Crematorium, *Megan Kitching*
- 41 Deep South Survival Art, *Cilla McQueen*
- 43 Outbreak Narratives, *Melody Nixon*
- 53 Winter Calls, *Ruth Arnison*
- 54 Ecology 221, *Ruth Corkill*
- 55 Our son of eighteen summers, *Claire Orchard*
- 56 Bathrooms of New Orleans, *Justine Whitfield*
- 63 Port Hills, Canterbury, *Elizabeth Smither*
- 64 ART PORTFOLIO *Conor Clarke*
- 73 Brown, *Sophia Wilson*
- 74 Sawmill Empire, *David Eggleton*
- 77 Ostrich, *Hayden Pyke*
- 78 Dear Life, *Medb Charleton*
- 79 Giant Soldier Man, *Olly Clifton*
- 86 Mona Lisa, *Richard von Sturmer*
- 87 Bhutan, *Nathaniel Calhoun*
- 88 Son, Sword, Chocolate, *Diane Comer*
- 90 Something Ends, *Michael Hall*
- 91 Never Been to San Francisco, *Antonia Smith*
- 92 [queens], *Sebastien Woolf*
- 93 Games, *Isabel Haarhaus*
- 98 Bubbles, *Owen Bullock*

99  University, *Wes Lee*
100 My Octopus Teacher, *Fergus Porteous*
109 Air-bridge, *Hayley Rata Heyes*
110 My parents on why we are not in the phonebook, *E Wen Wong*
112 ART PORTFOLIO *Zina Swanson*
121 Sirens, Stop, *Anna Reed*
122 Ultrasound, *Trevor Hayes*
123 a swarm of dots, *Mary Macpherson*
125 The Wedding in September, *Eileen Kennedy*
131 Kohekohe, *Janet Newman*
133 Bendigo, *Summer Gooding*
134 See John Run, *J.D. Robertson*
141 Somebody Do Something, *Wanda Barker*
143 The Round, *Zoë Higgins*
144 Bloom, *Bronte Heron*
145 Temaleti, *Mark Edgecombe*
146 and so I shape myself, *Lily Holloway*
147 John Campbell, *James Pasley*
154 Daytime Activities, *Joanna Cho*
156 Official Printer to the Government, *Erik Kennedy*
157 Third of March, *Molly Crighton*
158 Karamatsu, *Nicholas Wright*
159 Married, Widow, Divorced, Spinster, Nurse, *Sarah Natalie Webster*
169 Caselberg Trust International Poetry Prize 2021 Judge's Report, *Majella Cullinane*
171 Sea-skins, *Sophia Wilson*
173 Kintsukuroi, *Jenna Heller*

THE LANDFALL REVIEW
174 Landfall Review Online: Books recently reviewed / 176 EMMA GATTEY on *Two Hundred and Fifty Ways to Start an Essay about Captain Cook* by Alice Te Punga Somerville; and *Imagining Decolonisation* by Bianca Elkington et al / 180 HARRY RICKETTS on *The Mermaid's Purse* by Fleur Adcock / 184 TINA SHAW on *Sista, Stanap Strong!* eds Mikaela Nyman and Rebecca Tobo Olul-Hossen / 187 JACINTA RURU on *From the Centre* by Patricia Grace / 190 STEPHEN STRATFORD on *Life as a Novel: A biography of Maurice Shadbolt, Volume 2, 1973–2004* by Philip Temple

202 Contributors
208 Landfall Backpage et al.

DAVID EGGELTON

# Kathleen Grattan Award for Poetry 2021 Judge's Report

For poetry *can* make things happen—
not only can, but *must*—

writes Paul Muldoon in his poetry collection *Meeting the British*, denying the lugubrious W.H. Auden in his cups insisting on the opposite. Poems, then, are designed not to be entropic but rather to be bringers of communal energy and cultural renewal. There were close to 100 entries, all submitted anonymously for this award, and from a longlist of 24 I selected a shortlist of six. For me, these were the manuscripts that mattered in their accomplishment, their ambition, their devotion to the art of poetry.

'Tung' by **Robyn Maree Pickens** is a collection that teases with its hermetic lyricism as the poet listens 'at grass seed height' to things as they are and skilfully registers linguistic mutations, words under pressure, language that's slippery and gnomic and infolded. This is writing about strategies for writing about the contemporary: its poems dealing with the interconnectedness of things are provisional, baroque, deconstructed.

The fiery collection 'Spittle Glitter' by **Rebecca Hawkes** is similarly about language and experience in flux. Urgent and adrenaline-fuelled, loquacious and compelling, her poems communicate a passionate engagement with a world part tacky, part glamourous.

**Nick Ascroft** in his collection 'The Stupefying' displays a fine sense of the ridiculous, and tackles the absurdities and paradoxes of language with great gusto. He employs slangy wordplay and impossible rhymes. His is a purposeful awkwardness, upsetting neatly stacked apple-carts of consumer catchcry conventions and wrangling swarms of buzzwords to spendidly comic effect.

There's an extraordinary expansiveness, a bravura that is all-embracing, at work in the collection 'Naming the Beasts' by **Elizabeth Morton**. These are

poems of accretion, line by line. The sum total constitutes a kind of extended jeremiad about 'Nature', where concerned environmentalism has replaced Romantic transcendentalism. The poems in this substantial manuscript go worming through the world's matter as if through a rich compost.

'Late & Later' by **C.K. Stead** is a collection of occasional—yet definitive—poems that's wry and epigrammatic, polished and assured. It reads as a taking stock, a rounding up, a last hurrah, with an expert, incantatory use of syllabics that serves to hold its glancing perceptions together. It's a colourful parade of the Higher Anecdotalism, and a stoic display of minding p's and q's that brings to mind Philip Roth's observation: old age isn't a battle; it's a massacre.

However, I selected as the winner of the Kathleen Grattan Award for Poetry for 2021 the manuscript titled 'Night School' by **Michael Steven**. The poems in this collection read and feel as if they have been quarried out of silence and watchfulness and long contemplation of the dark night of the soul. Laconic yet measured, his sombre poems have a classic weightiness and a burnished elegance. Beyond this, he writes like someone fleeing an infernal and damned city, one about to be razed by a vengeful Old Testament God, and yet he bears lyrical and eloquent witness. Here are artfully-limned revenants knocking at the wound-up car window, and ancestor figures with feet of clay fallen from their niches.

This is the poet as pilgrim, traveller, and astonished survivor. His poems deal with with New Zealand masculinity, relationships between fathers and sons, the self-destructive tendencies of doomed youth, ways out of nihilism, faith, hope and literary legacies. His sonorous verse has an impeccable lapidary quality, each word fitted like a stone in a wall. Phrase by phrase, sentence by sentence, writing with a lucid precision, Michael Steven patiently builds up his world view, always making sure we are with him, always allowing us to share the understanding:

> My thoughts returned to my own son.
> When I looked back, the farmhouse was empty.
> There was no mother hanging out washing,
> no child at play. The gold plains burned.
> I carried the father's silence away inside me.

EMMA NEALE

# Landfall Essay Competition 2021 Judge's Report

The 76 essays entered for this round of the Landfall Essay Competition were of such high quality that I walked bald circles in the carpet as I tried to outpace my own indecision. I began to feel increasingly relieved that this is the last time I'll be judging the contest, as it all felt less like 'spoilt for choice' and more like 'speared, suspended and splintered'. The healthy number of entries means that in stepping down I am like a rat that leaves the ship not when it's sinking but when it's transforming into something like the magical airborne galleon at the end of the 1953 film version of *Peter Pan*. Foolish rat! As the next judge, Lynley Edmeades, is herself a brilliant essayist, the competition is likely only to become stronger as readers absorb her reports over the years.

Areas explored this year included everything from life in the fashion industry; PTSD related to racism and the long aftermath of colonisation; the nature of traumatic memory; housing prices; relationship problems; miscarriage; the divisions on the publishing scene between genre, children's and perceived-to-be-literary writing; the effects that Covid has on our sense of time, aspirations and life choices; sexual harassment; poetic childhood recollections; and working as a comedian while solo parenting. This list of course is just a sample, and it was dizzying to work through the full range of worthy and often important, controversial subjects.

As an essay reader I look for 'precision and passion'. Precision in this context includes both the persuasive assembly of accurate research and the concision of writing style.\* (Concision can itself of course be poetic in that the right simile or metaphor may seem to land with the exactness of a laser pointer's red bead.) Some otherwise competent essays, I felt, either needed a more linguistically bold and engrossing sense of the writer to lift them above a well-collated list; or, in the cases of several beautifully written slices of

---

\*  I'm repeating this line about precision and passion from a talk I gave on the essay form to the Dunedin/Ōtepoti branch of the NZSA in July 2021: to anyone reading this who attended that talk—I still haven't printed that line on a T-shirt.

autobiography, needed to stretch beyond memoir, perhaps to suggest how the experiences might fit into a wider cause or paradigm.

This year, all of the essays that I wanted to champion marshalled research, facts or memories into well-paced coherent work that also gifted us with moments of lyricism and insight. They spoke subtly of our social pressures and relationships, keeping the reader drawn in as the writing uncovered knowledge and response with each paragraph. What they revealed could be historical, political, musical, literary, artistic, philosophical, biographical or even entomological information; or the thematic associations that clustered around a central fascination; or a greater intimacy with the writer.

With the best essays we have the sense of being carried along by the writer's own curiosity and eagerness to unveil more of their subject. We absorb less readily, I think, if topics are presented as impersonal lectures, where bales of data are churned out, sliced into shape and dumped, as dry and prickly to the human palate as hay. Instead of tractoring along great gobbets of facts, the winning essays here ride the sometimes sombrely persistent, sometimes heady impulse of discovery, and yet also offer quiet introspection and reflection.

*First place*
**Andrew Dean**, 'The New Man'
'The New Man' is a reminder of the complexity of political, social and religious pressures that many immigrants and refugees have carried with them to Aotearoa throughout modern history. As he traces his grandparents' background, Dean looks into the shamefully long record of anti-Semitism that has driven families into nomadic exile across the globe. The essay also exposes the incoherence, inconsistency and contradictions within racist/anti-Semitic rhetoric. The character of a possible ancestor materialises from the author's research: an elusive figure persecuted by the atrocious ideology of fascism, which, in its efforts to debase and erase Jewish identity, creates the necessity for self-reinvention, for artful elusiveness, as a matter of self-defence and survival. The essay deftly combines scholarship and personal memoir, wearing both somehow lightly and yet with an enlightening effect, despite the traumatic history of pogrom, war, exile and loss.

'The New Man' may be found on page 10.

*Second Place*
**Claire Mabey**, 'Holy Smokes'
My doctor father was so actively involved in ASH (Action on Smoking and Health) in the 1980s that he made annual visits to my school to speak to the fifth form liberal studies class, hoping to dissuade teenagers from taking up smoking. His pièce de résistance was to present cross-sections of both healthy and cancerous lungs, their dissected wings conserved in Perspex blocks. The preserved smoker's lungs were a revolting sight: like enlarged, misshapen leaf-brown fungi, they seemed to come from an alien planet. Dad had at least one successful convert: I was put off cigarettes forever. And yet … the essay 'Holy Smokes' is so strong that it broke through my inherited resistance. With its understanding of the potency of metaphor, and its ability to let several preoccupations dance around a central axis, it begins as an essay on smoking but quickly, and with dexterity, evolves into a poignant, vivid and intimate meditation on—among other things—art, time, connection, exhaustion, family and mortality. The tendrils of lyricism (and the cameo role of a cautioning oncologist) help the essay to 'get away' with not directly mentioning the corruption of Big Tobacco—though I feel a concerned, daughter-of-my-father moral urge to mention its absence here myself.

*Third Place*
**Susan Wardell**, 'Mary, Me, and the Bees: In search of the good settler'
A beautifully calibrated discussion of gardening, beekeeping and trying to find acceptable historical role models for Pākehā identity, this essay offers a biography of Mary Bumby (the first European to bring non-native bees to Aotearoa), a gentle thread of environmental and social questions, and some transporting passages of personal reflection. These passages lift from the historical account of both Māori and Pākehā beekeeping practices like mellifluous prose poetry and so lend the 'bronze' of third place a glint of its own gold too.

*Highly Commended*
**Norman Franke**, '"Dream of Birds …": Research poetics, Messiaen and posthistoire behind a Hamilton garage'
As this is the most obviously academic of all the essays entered, its audience

will be more niche than the main placegetters. Yet its discussion of research, poetics and French composer, organist and ornithologist Messiaen and his influence on composers here in Aotearoa, also conveys the author's own love of the nature of research and scholarship so clearly that the enthusiasm is infectious. The formal diction and the digressive style ask more of the reader than almost any other submission in this intake, yet the expansiveness and variety in this essay are both impressively, and somehow invitingly, erudite. Franke's capacious knowledge of music, Messiaen, birds, languages, fairy tale, liturgy, philosophy and much more besides, means the essay can bear the kind of repeat readings that befit lyric poems; more perceptions and interpretations seem to float from the sentences as you mull them over.

**Susanna Elliffe**, 'No More Elephants'
Only two or three structurally bold essays were entered this year, and this is by far the most successful of the less conventional submissions. Its numbered paragraphs give the air of a formal, restrained documentation of a subject, and yet, as these paragraphs are often lyrical rather than factual, the list is also a gesture of serious or technical play. The lyricism undermines the sense that we can itemise and order grief in the ways we might catalogue facts about the flora and fauna of our beleaguered world. This essay interweaves human psychology, poetry, zoology and intimacy as it examines the loss of a close friendship, running this together with the diminishment of a keystone species in a plangent kind of duet where the author sings to absence.

*Commended*
Ethan Te Ora, 'White-knuckled Guilt'
Alexis O'Connell, 'Through the Mist and into the Sunlight'
Jayne Costelloe, 'Alchemy of the Airwaves'
Bonnie Etherington, 'A Fried Egg in Space'

ANDREW DEAN

# The New Man

I moved to east London in early autumn 2018 following the hottest summer in a decade. I'd had one last valedictory season in Oxford: long evenings in the garden, punting on the Isis, cricket in the fading light. By September, the leaves were beginning to turn, and my long-delayed departure began.

In May I had signed a lease for a room in a shared flat in London. The whole place would be renovated over the summer, I was told. The owners had initially promised that the work would be done in a couple of months, by August at the latest. After the deadline passed they told me they needed more time. September came and went. By early October, when I eventually moved in, the carpet was yet to be laid, and all of the rooms—except mine—were piled floor to ceiling with unassembled parts of a house. There was plasterboard in the living room, timber in a bedroom, cushions and pieces of chairs in the bathtub.

In the building site beyond my room, nothing worked. Turning on the kettle would plunge the living room into darkness. The washing machine's spin cycle cut power to the downstairs flat.

Gurgles and watery clanks sounded through the night. At first the noises came from my radiator, but soon they were coming from somewhere deeper, harder to determine. I'd wake up to a heave, a clank—and then silence. One evening in November, sections of the kitchen ceiling fell in, spreading a fine layer of dark grey dust over the floor and bench.

In those first few weeks in London I would wake each morning to find teams of labourers in the house. The beginning of the day's work would be heralded by Polish folk ballads. The workers would stay all day, hammering and shouting, smoking out the window. About twice a week a man named Marion would come in the later evening, after all the other men had left. He would work until two or three in the morning, Radio Three playing from his plaster-spattered stereo. One night, against the lamplight, he told me that today was the second anniversary of his wife's death. This was difficult to

recall, he said, not only because she was the only woman he had ever loved, but also because their son had undergone a mental collapse following his mother's death, and had spiralled into drugs and crime. The son was now in prison in Romania, he said. I didn't ask after his daughter. He told me she had recently been disabled.

Marion's struggles did not help the air of unreality that had settled over my life. Between the rubble, the ballads, the leaks, the plasterer's ghosts and everything else, I had the sense that nothing was quite as it was, or should be. Perhaps if I went upstairs to the empty shell of the loft, I thought, I would just slip across to the other side. There would be one great clank, the power would go out again, and that would be it for me.

Almost imperceptibly, though, the other world that had opened up before me began to close itself off. The renovations were completed (if never quite finished), the carpet was laid, and the plumbing and electrics were fixed. A new washing machine was installed. I heard fewer Polish folk songs, and then eventually none at all. The last I saw of Marion was his departing figure after he pushed the keys through the mail slot.

I assembled pieces of furniture from around the house until I had something like a bedroom. There were reminders of the time just past—pencil marks on walls, unpatched holes in the ceiling—but it seemed as though those odd few weeks were behind me. Another life, which had felt so close, slipped out of mind.

★

It was in October that I first cycled along Cable Street. This is the East End proper: the skyscrapers of the City of London nearby dominate the squat council flats of Whitechapel. I had come here because my father's family had lived around Cable Street between the wars—or so I had been told. They had been part of the extraordinary mass exodus of Jews from the Pale of Settlement in Eastern Europe that took place in the five decades from around 1880. Escaping persecution and pogroms, Russian Jews moved all over the world, to the United States in particular. Around 150,000 went to London. By one estimate there were more than 200,000 Jews in London in the 1930s, most of whom lived in the East End.

What little I knew of that generation of emigrés was filtered through my father's half-told stories. His maternal grandparents, Harry and Jane Wislaw,

were in the *schmatte* trade. Harry was a tailor, Jane a seamstress. This was a common line of work for Jews at the time: immigrants in the slums of London's inner east performed the labour of Savile Row. After the war, Harry and Jane left behind a bombed-out Britain to live out the remainder of their lives in suburban Christchurch, New Zealand. For my father's bar-mitzvah they gave him a bicycle. His stories of them end around then. About my father's paternal grandparents I knew little other than what I could intuit from my grandfather's contemptuous asides.

Wandering around those streets, past estate agents and off-licences, I couldn't find anything that matched my image of how life might have been here between the wars. Whatever sense I had was probably formed by my memory of a single photograph of my father's early life in Britain. It's black and white, and he's being wheeled in a pram down a London street. Everyone looks cold. It might be winter—or this might just be what England is like. In the background are a few trees and a detached house.

It began to dawn on me, here among the council flats, that the stand-alone house suggested that the photograph was probably not taken in London after all. Villas and bungalows are more the terrain of my father's later home in Westminster Street, Christchurch. What I thought was the postwar chill may well have been the breeze blowing in from the Pacific.

My memory-work was doomed from the outset, of course. This part of London has been serially made over in the waves of destruction and construction that mark modern British history: the Blitz, inflows and outflows of migration, Thatcher, and the tentacular growth of the City. Any traces that could have remained would almost certainly have been made over and then made over again in this cycle of demolition and rebuilding.

Few Jews remain in the East End now. After the war, with much of the area destroyed by German bombing, most moved northwest, to neighbourhoods such as Golders Green. Some emigrated, including Harry and Jane. Newer arrivals, largely from Bangladesh, settled in the East End in the 1960s and 1970s. Where there were once 150 active synagogues in this area, there are now four.

What was I doing here? It should have been obvious that I wouldn't find traces of interwar life hidden in the brickwork, and not only because of everything that had happened in the intervening decades. In reality, I knew

next to nothing about the figures whose steps I thought I might be retracing. I had never even seen photographs of them. All I had were my father's recollections, vague and sometimes painful, which shimmered into and out of significance. He used to call his grandparents from a phonebox in front of a cemetery on Grahams Road, Christchurch. His bicycle was stolen from outside the hospital soon after their deaths. Their graves were in Linwood Cemetery. Harry ate little other than steamed fish. They argued in Yiddish.

Leaving behind the council flats, I searched for something that I knew definitely was on Cable Street. Near Shadwell Station there is a mural several storeys high, covering one end of a row of terraces. It commemorates the 'Battle of Cable Street', the anti-fascist demonstrations against Oswald Mosley's Blackshirts in October 1936. Mosley's 3000 Blackshirts were met by 50,000 protesters, and somewhere between 100,000 and 300,000 more further along the route. Despite attempts by police to clear the way, the march was eventually abandoned.

The mural depicts a city street in ferment. Police horses charge protesters while packed crowds fight the massed authorities. Banners are flying, bodies are captured in motion, and pieces of machines wheel through the crowd. Above, residents hurl rubbish from the upper windows—glass bottles, propaganda leaflets and the contents of chamber-pots.

It was the Jewish presence in the East End that had turned it into a target for the growing fascist movement in Britain in the later 1920s and 1930s. Mosley formed the British Union of Fascists in 1932, and it quickly became the nation's largest extreme right-wing group. In November 1933 a front-page article in the BUF's newspaper announced details of the Jewish conspiracy against Britain.

The *Daily Mail* in January 1934 ran the headline 'Hurrah for the Blackshirts', under the name of the newspaper's owner, Viscount Rothermere. The immediate prelude to the events of October 1936 was a campaign of hooliganism led by the BUF and other affiliated groups, including window-smashing and attacks on Jewish-owned shops. Street violence that targeted Jewish residents had become common in the East End by this time.

While the Battle of Cable Street ended in defeat for the BUF, it led to a further radicalisation of the far right. BUF meetings swelled in the East End.

Mick Clarke, a local fascist leader, declared at one meeting: 'London's pogrom is not very far away now. Mosley is coming every night of the week in future to rid East London and by God there is going to be a pogrom!'

In going to Cable Street I was undertaking my own minor version of heritage tourism. But my trip was ultimately less about looking for what I might find than it was about looking for what might no longer exist. I couldn't seriously expect, here in the East End, to find the place my family had left. Another way of putting it is that there's no East End for me to find. Discovering what you left behind is not the kind of thing that happens to my father's family, to Jews. There's no family farm, no little church or village shop. The temple was destroyed and, much later, a homeland invented. I went home and picked up a curry on the way.

★

To support a new research project on Jewish comedy, my job in London came with few formal responsibilities. I quickly found the autonomy to be a mixed blessing, however, as I had little idea where I was going with my work. As is typical with academic positions, I had been hired on the strength of what I had just finished rather than what I would now be starting. The two-year contract was too short to require tangible results, but too long to ignore that prospect outright. My manager's expectations were opaque, communicated mainly through raised eyebrows and extended pauses. *And what are you planning to work on next?*

I slowly came to understand that my project was unlikely ever to be completed. The topic *could* appeal to me, but I didn't know how to write something new about it. It was too vast, too well covered, and anyway I probably didn't have the skills. I don't speak Yiddish, and my knowledge of Jewish biblical material is negligible. I never actually announced this thought to myself or anyone else, but my habits nonetheless began to organise themselves around it, like water around a rock. Month by month, my working hours became shorter and my weekends longer. I went to Venice three times in the spring and played cricket midweek in the summer.

I took to haunting the British Library, rummaging through its catalogues. In this purposelessness masquerading as research I consulted joke books, pamphlets and tracts, newspapers, histories of comedy, histories of Jews and

anti-Semitism in Britain. For a brief moment I thought about trying to learn Yiddish—then booked myself another holiday.

One of the far-right tracts I read was *The Alien Menace*, published in five updated editions between 1928 and 1934. Written by Lieutenant-Colonel A.H. Lane, each edition of the book raises alarm about recent immigration. In the first, just under a hundred pages in length, Lane writes: 'This book might be called "Britain for the British".' What follows is a heady mix of racial pseudo-science and decreasingly veiled anti-Semitism. In his preface he claims that recent migrants are 'generally the scum of Central and Eastern Europe'. This is 'not intended to be anti-Jewish,' he says, but rather 'anti-alien and pro-British'.

Over time, in line with the radicalisation of anti-Semitism in Britain, Lane became more virulent in his denunciation of Jews. One of his central claims was that Jews are at the origins of the scourge of international communism. He repeatedly refers to Karl Marx as 'the Prussian Jew'. He says that Bolshevism is 'controlled by a combination of internationalists in which those of the Jewish faith predominate'.

Paradoxically, Jews are also ruthless capitalists. He worries that 'our most important industries … are now wholly or partly controlled by German American Jewish interests'. Jews, we discover across the fifth and final edition's 250 pages, are all of these things at once: politically powerful and physically degenerate, exploitative controllers of capital, ruthless communists and impoverished vectors of disease, directing the media yet curiously unable to be viewed kindly by the ordinary British man.

Reading such tracts was both amusing and banal. In time, I became immune to the claims the authors were making. It was as though their rhetorical strategies had been forced through a mincer. As I confronted a mush of rhetoric day after day, the writing became uniform, a series of gestures that amounted to the same thing—another claim that Jews run the world, that the body-politic is withering away, that 'we' are on the brink of a race war, that Jews use Christian blood for matzo.

I read deeply into the appendices of *The Alien Menace*. With Lane's army career now behind him, he had the time to assemble a list of newspaper cuttings that reported immigrant crimes. Each new threat indicates yet

another moral crisis: from 'Deportations' and 'Illegal Landings, etc.' to 'Thefts, etc.' and 'Fraudulent Trading, Bankruptcies'. Alongside my fair-minded guide, I learnt to be as worried about 'International Thieves and Swindlers' as about those foreign-run centres of vice, 'Opium Dens, Night Clubs, etc.'

One case in *The Alien Menace*, under 'Passports, etc.', caught my eye. On 1 January 1927 the *Daily Mail* reported that a man who had gone by numerous different names, 'an electrical engineer of no fixed address', had been convicted of 'entering the country with an irregular passport and stealing a passport'. He was said by the prosecution to be 'a runner or messenger for the Communist Party'. His sentence was six months' imprisonment and a recommendation for deportation. The clipping contained a brief biography:

> [He] registered in England as a Russian in the name of Neumann in 1916. Neumann was believed to be his correct name. In 1918 he appeared to have gone to America, and in 1924 returned to London, living in the East End. During the general strike last May he was very active. When that was over he left the East End and went to live with a friend named Prowse at Tottenham, N. Last June he stole Mr Prowse's passport, and travelled on the Continent with it. Last year he bought a passport for 500 francs from a Frenchman, and went with it to Germany and Holland, and last Friday arrived at Harwich.
>
> Detective-Sergeant Foster, of Scotland Yard, said that [he] had used the names of Gurowitz, Neumann, Newman, Caquin, and Prowse. He had tried to become naturalized in America.

Lane was presumably drawn to this case for several reasons. The first is the series of lies the man told about his identity. This menace had slid in and *lived among us*. The second is the suggestion that this man was Jewish—several of his names, along with his origins, and where he had lived in London, imply as much. The time of his arrival, for Lane, also showed his cowardice. The man was probably seeking to avoid conscription into the Tsarist army, and Russia was a British ally for the first three years of the war and a bulwark against communism. Finally, and worst of all, are his political leanings (which of course confirm his Jewishness). His actions during the General Strike, and his decision to clear out of the East End afterwards, show that he was involved in fomenting trouble on behalf of Judaic class warfare. A lying, rootless, disloyal, communist Jew.

What was I looking for at the British Library? If I had come looking for the remnants of my family, Neumann is as close to an adoptive ancestor as could be imagined—a Jewish everyman at the moment of crossing over. In the blurred outlines of this man's story I saw shimmering into view a figure of the many human lives that lie behind the great historical forces of the century. He seems to float on the winds of the era: persecution, war, emigration, exile, Bolshevism, strikes. A person with no apparent source of income and no clear past, he had been blown about in the madness of a world that had lost its mind. A new man, washed clean both of and by history.

There is a word in Yiddish for the kind of character Neumann was: *luftmensh*, a man who lives on air. A *luftmensh* can come from anywhere and with any purpose: a criminal or a cod-philosopher; an organ-grinder or a down-on-his-luck businessman; a dubious inventor or a tramp. He is as likely to turn up to a Seder in rags as he is to arrive wearing a gold watch. He may never be heard of again or he may be impossible to get rid of. The *Guardian* reported that when Neumann arrived in Britain from France, he presented himself to immigration officers as 'an electrical engineer'. He said that 'he had come to this country to put a new blowlamp on the market. He was unable to speak a word of French and had no papers on him relating to any blowlamp.'

There was an odd coda to Neumann's story, which I discovered in the fragile collections of the British Library's newspaper reading room. It seems that he or someone close to him later told the *Sunday Worker* that the police had attempted to 'extort' a confession from him. The newspaper reported:

> He has been on a bread-and-water diet. His cell is in a filthy condition, and he is not allowed a mattress, but has to sleep on the floor. No doubt this is intended to make him more amenable to the third degree inquisition.

Despite these conditions, Neumann still found time to send 'fraternal greetings to the Workers, both British and Chinese, who are struggling for the overthrow of capitalism'.

The *Sunday Worker*'s accusations of police heavy-handedness led to a libel case against its editor, which the police eventually won. It turned out that the police had no access to Neumann's cell and that the prison regime was no different for him than it was for anyone else. This electrical engineer had

been detained as little more than an ordinary thief. As a later retraction noted: '[T]he statements in the original paragraph were quite unjustified.'

What became of this *luftmensh*, this man of air? He was never deported, despite the court's recommendation. He went on to have ten children in England, who went by some of the many names Neumann adopted. I have every reason to believe that one of the children was Lionel Dean, my paternal grandfather. While I will never be certain, there are enough parallels in the reporting on Nathan Neumann—name, job, origin, year of arrival—to suggest that he was in fact the *luftmensh paterfamilias*. Some of my cousins are named Newman, although they've discussed returning it to what they believe to be the original family name, Neumann. Then there are the Deans, of whom I am one. There may well be some Caquins, Prowses and Gurowitzes out there.

There has always been some unspecified hint of scandal in my family associated with Lionel's father. Lionel didn't say much about him, other than that he was no good. *No good* was in fact one of my grandfather's phrases. It was never that clear to me what he meant by this—a shirker, a scrounger, a liar, a *luftmensh*. *My father?* he would say. *No good.*

*

The only time I have visited the graves of my father's other grandparents, Harry and Jane Wislaw, was when I was in Christchurch on a book tour to give a talk about nostalgia in politics. I asked the audience: what might it mean to be living in the past? Are we in a romance with what can never be called back, and with what might never have existed? Whenever the audience tried to steer me back to politics I found myself speaking embarrassingly from the heart. We only know what we want from what we once wanted, I told them, as I felt myself slipping into another life entirely: when I feared harm and took shelter in my parents' arms. My editor, sitting in the front row, looked vaguely alarmed.

I had been out with my parents to the Linwood Cemetery, on the east side of Christchurch, before the talk. Both my parents have relatives buried here, on different sides of the cemetery. The graveyard is a record of early colonial immigration, the plots split into different religions (separated even in death). On the south side, with a view back towards the city, are the grand

nineteenth-century headstones of the early Anglicans. Halfway up the hill, to the northwest and near a major road, are the Catholics.

Most of the graveyards in Christchurch were damaged in the major earthquakes of 2010 and 2011. On Linwood's sandy ground the land had warped, lifted and dropped thousands of times, flattening headstones and breaking open tombs. The monument to Thomas Dixon (beloved husband of Janet, d. 1918) lay in three pieces next to his distended concrete grave—the pillar, the capital and the rounded stone decoration. The tomb of Clara Clark (d. 1906, beloved wife of W.H. Clark) lay on its side.

There are few visible signs of Jewish life in Christchurch. This is a city in which the spire of the cathedral was once visible from kilometres away in every direction. However, in Linwood, a series of low monuments, all in black, record the presence of Jews from the settlement's early history—Freidlanders, Schwartzes and Woolfs.

It will always be a shock to see the Star of David in suburban Christchurch. Whatever led these people to come to the end of the earth was much like whatever led Neumann to leave Russia. It was part of the same historical process. My father, who was with me, stopped in front of the grave of Harry Teplitzky (d. 1977, immigrated 1920). 'Oh,' he said. 'Tip.'

Eventually we found my father's maternal grandparents. The flat stones were undamaged. Harry Wislaw (d. 1965, immigrated 1953), a tailor. Jenny Wislaw (d. 1970, immigrated 1953), a seamstress, known as 'Jane'. A Star of David with simple text on a black background. We placed pebbles on the graves and waited in the autumn breeze for something to happen.

Amid all the destruction, none of the Jewish graves had been disturbed. The monuments here are simpler, hidden away, less vulnerable to shaking. They face a different direction, from east to west. For once, here in Christchurch, the Jews had been left undisturbed.

VANA MANASIADIS

# Small Shaft of Sun: Skylla tells the story of her favourite

Winter Street is the name of hers the quiet one.
Her name like systems, like Milky Way because
 she keeps me to our habitat συμβίωσεις, fasts me
to space, to the starlights to the ground,
 the crystal galaxy that pulls our bodies into.
                    While the others try to keep for
room, Winter Street curls into fleshy belly my,
and warms the difficult space my. When is
sleeping she, και με ζεσταίνει, she feels small
shaft of sun. Not hungry, not wanting any of
things except the fitting that we do.
             Winter Street doesn't ask much. When
is sore she, trembles she, but doesn't make sound
becomes as small as little beating. Becomes the
small fur to the corner, tight to the surface. Ναι,
μ'εμπιστεύεται, και τα μάτια μας γίνονται
one ocean single. It is simple.
              I take her for walking to the coast,
when the others are in sleeping, and let breathe
her salt. She is the only of the six ones who can
to separate from me. Βγάζει τα μπροστινά της
πόδια και μετά τα πίσω και γίνεται ξεχωριστή
  her paws imprinting ice-lands.        And I
  to let her run off along the water lines, along
the tongues glacial that look as concrete piers,
that look to bring the fishing boats. Τρέχει σαν
λαγός her ears backwards to the constanting winds.
                Και κλείνω τα μάτια μου ξανά

και ξανά να τραβήξω την εικόνα της, την αργή
ταινία των κινήσεων της because         I know
for sure the day I have to leave behind to stay her.

It is not like the myth.

FRANKIE MCMILLAN

# What extremely muscular horses can teach us about climate change

She tells me she's read about it, this link between horses and climate change, but when she went to the internet a message popped up, *Page not found*, and all she can imagine is that the horse's breath is a ferocious wind that lays the desert or the tundra or whatever to waste, and really her mind is saddled up with the strangest of facts: how an octopus has three hearts, how bees sleep in pairs and hug each other's knees at night and … Stop right there, I tell her, because I know what's coming next, it will be about the gorillas making a new nest each night in the trees, and the male sleeping below to ward off hyenas or other dangerous beasts, and she lies on the double bed in the motel room, far far away from the desert or tundra or jungle or savannah, and she points to the single bed by the door and tells me if I were the male gorilla I'd be sleeping right there, ready to defend the troop, and I shake my head: *troop?* But she's read about it, it's the collective noun, so then I take off my belt and trousers and I ask her if I'm not an extremely muscular fella and *Page not found* she says, *Page not found*.

BREE HUNTLEY

# A Wise Man

He has a fantasy in which he is giving a lecture to a crowded auditorium; a lecture about what he is not sure—it is a silent fantasy—but which is being received with rapturous enthusiasm; and in moments of despondency, when he can't shake the feeling that his life has been marred by some terrible mistake deep in his past, that everything could have, should have happened differently, he wonders if he was meant to be a professor.

  But when he mentions this to his daughter she reminds him that to become a professor is no easy thing; it requires many, many years of study—something like ten years at varsity all told, so more than twice the time he spent at high school, a period of his life so excruciating in its tedium, so relentless in its petty humiliations that he wouldn't repeat it for a million bucks; and, she adds, there is the matter of what being a professor actually entails—it's not all standing at a lectern, holding forth; in fact, professors spend relatively little time lecturing; most of their time they spend in their offices alone, writing about things he wouldn't believe anyone bothers to write about; and as she continues to talk he thinks about the time his mother forced him to study every night for a month so that he wouldn't leave without his School Cert; how he had hated sitting at that little table in the hallway, telephone and knick-knacks shoved to one side to make room for his textbook, reading the same sentence over and over again while everyone else laughed at the television in the next room; how determined it had made him never to work a desk job.

  So it is not so much that he wants to be a professor but that he wants to be a certain kind of person: the kind of person who can speak on any topic at length and with authority, to whom one can address any question and receive an answer; a wise man, he supposes, but not just any kind of wise man—one who is also a man of the people, who doesn't allow his superior intellect to cut him off from ordinary folk; one who is at home anywhere, who can tailor his speech to suit a beggar just as well as a priest; who, what's more, doesn't

have an office, never spends a moment at a desk, never even spends more than a day in the same place; is always on the move, travelling by whatever means are available—on freight trains alongside tramps, on ships alongside sailors—with all his belongings in a knapsack on his shoulder; needing no books, no papers, having committed everything he's ever heard or read to memory so that he can draw upon it at will; yes, a travelling lecturer, who can arrive in town in the afternoon and by nightfall have convened an audience; perhaps in the town square if the weather is mild, or in the home of a prominent resident—the mayor, maybe, or a justice of the peace; a varied audience—all ages, all walks of life, like in one of those old Dutch paintings, where men and women carouse amongst children and dogs.

And although he is at home anywhere, what the travelling lecturer likes most of all are small villages, or rather settlements so tiny that they can't even be called villages; settlements that aren't on maps, which can only be accessed on foot, which reveal themselves to him only after several hours of journeying across undulating woodland, twigs cracking satisfyingly under his boots, when quite suddenly the trees are replaced by mild blue sky and miles of gleaming pasture, and the twittering of the birds joined by the mournful lowing of a cow; the kinds of places where there is no town square, where the thing to do is knock on the door of the first dwelling one sees and make the acquaintance of the master of the house—a farmer, typically, with a great black beard, the kind that is so voluminous and dense that it could be hiding all manner of things (spiders, coins, a knife); a farmer who is boyish with excitement at meeting a travelling lecturer, who immediately instructs a farmhand to invite the surrounding households to a feast that evening; a feast to which the guests arrive piecemeal, in buggies and on bicycles, toting flagons of mead and mulberry wine, until by nightfall the modest stone cottage is overwhelmed by people: people leaning against doorframes, perched on barrels, gorging on rabbit stew, mashed turnips, roast beef; talking and laughing between mouthfuls, loudly, so as to be heard above the others; and all the while the travelling lecturer remains apart, in an armchair in the corner; silent, watching, like a king in disguise; and they all avert their eyes from him out of politeness, with the exception, always, of a child who stares and points and has to be scolded.

But when the food has been cleared away, and the farmer whose house it is announces that a guest is going to address the group, they all turn to stare at the travelling lecturer as shamelessly as the scolded child had; and when he begins to speak they all fall silent, in awe at his verbal skill, at how he takes old figures of speech and combines them to make new ones and draws connections between things that seem different to show that they are not in fact different; he is like an athlete, like an acrobat, like a magician; so impressive that when he asks if there are any questions they all immediately raise their hands; and after gazing for a moment at all the eager faces he calls on a frail old man, who offers his deepest thanks for the talk and compares the travelling lecturer to a missionary carrying the light of knowledge into the darkest corners of the globe, and only then asks his question, which is something like 'what is law?'; and with that the travelling lecturer starts up again, except this time it is spontaneous so even more impressive, and this goes on until everyone in the audience has asked a question, at which point the farmer says that they have detained the travelling lecturer long enough, that morning has broken and he will need to be getting on his way; and indeed when the travelling lecturer looks to the window there is light at the edges of the curtains and it looks like it is going to be another beautiful day, and, taking the pastries that the farmer's wife has wrapped in a warm cloth for him, he sets off.

DEREK SCHULZ

# Gratitude

Following an experience of beguilement on this scale, what are you to do on the subject of gratitude? Begin by bringing her little gifts of empathy—a strand of red lace—that stopped watch—your lucky stone. I don't know why this works, but strew them around a little, as if nothing has begun going on. She'll know you know she knows, this isn't all about seeing through the light of day, so gather your contrariness around you. Her oranga is yours to attend, but remember, she won't look anything like herself. Until that very last moment. When there isn't one.

ROBYN MAREE PICKENS

# As if held (fullness)

which they keep in their arms
which they ke-ep in their a-rms
      as if sung
or hung like skeins on twine rope
each idea a chain a cellar a vein of worms a green vein
it's where the springs are & everyone is there

if Venus was a bear
if Mercury was in everyone's third house
for some earth witch duration
                              the atmospheric river at your knees
   in a corner of your mouth
  among a herd

all the other languages
especially herbs
accumulate in your mineral body
      as thermodynamic potential
                      as oyster opener

AIRANA NGAREWA

# Ihi Wehi Wana

'See that car, ow?' A lime-green beetle puttered into the distance, barely making the speed limit. 'Lady in the front winked at me. Almost crossed the centre line she was so lost in my eyes.'

'Bro, she looked seventy.'

Māui shrugged his shoulders. 'My swag crosses generational lines. What can I say?'

The brothers rested atop a bridge, still dressed in their school uniform, shirts hanging over their shorts and socks pulled up to their knees, watching the cars drift by, dreaming up love stories. Or whatever you call the not-so-quiet fantasies of sixteen-year-old boys. The night would soon grow late and they'd stay there, trading fictions, blasting homemade beats on a Bluetooth speaker. A kind of karanga for this rural place. The wops.

'See that one?' A painted rental sailed into town, the waka decorated with all sorts of surfer imagery. Palm trees and sunrises and lava lamps.

'With all the girls?'

'Not girls, bro. Women!' Faithful winked at his brother. 'Should've seen the hungry eyes they were giving me. Looking me up and down, licking their lips. Was like I was a steak or something.'

'Grade A meat, you reckon?'

'Better than Grade A ... Muttonbird.'

'Bro, you smell like muttonbird.' They cracked up laughing, remembering the last time one of their neighbours cooked that devil fowl, stinking up the whole block for a month. 'And anyway, they were probably looking at me. I was stretching, you know, showing my abs.'

'More like showing your undies.'

The banter went on endlessly, their little world alight with humour, their voices most passionate after a joke, their eyes most alive after a laugh. There were few joys in this rural kingdom more soul-warming than the company of

a like mind. A brother from another mother. God knows the boys had struggled everywhere else.

In the classroom. A fart in a test, no matter how impressive, meant an automatic *Not Achieved*. If you waited until all the windows were closed, you even got a bonus letter home detailing the event in hilarious detail. 'Three times Māui pressed his buttocks into his chair …'

In church. The deacon straight up fainted when Faithful screamed: 'It burns!' at his baptism.

Even on the sportsfield. Turns out undies on the outside was not the official away kit.

The brothers were Māui incarnate. Twenty-first-century edition. They knew how hard life was in these parts and had come to know the mauri of a little glee. Just how far a joke could carry a car on an empty tank, two parents in a row, a couple of boys who'd been told they were no good. A waste of space.

'See him, ow?'

'That young guy?'

'Fella looked like Billy T. James had a child with a rake. Same moustache and everything, just skinny.'

'Pretty sure that guy was a teacher back in the day. Remember seeing him and wanting the same mo.'

'Should've grown it.'

'I tried. Came out red.' They exploded with laughter, almost losing their balance, almost falling into the river beneath them.

'No way—you're a ginga?'

'Yeah, honest. Was red as.' They laughed again. 'I looked like an off-brand J Geek.'

Māui, seeing his opportunity, broke out some bad dance moves, moonwalking along the road, spoofing the J Geek classic as he went. 'I'm a Māori dancing cross a bridge. Got no money for my sandwiches.' Faithful, getting caught up in it all, jumped in with a harmony, eyes closed, singing into his fist. 'Do I ever ever get annoyed?'

A beat-up ute slammed on its brakes, the driver smashing his hand on the horn, calling the brothers from their daydream.

'This ain't Spark Arena, boys. Get off the bloody road.'

'Our bad, sir,' the boys replied, darting quickly out of the man's way, posting themselves back upon the barrier of the bridge, waiting for the ute to disappear. Unappreciated again.

'Never mind him, ow. Fella's stressed. Probably just praying that broken-down thing gets him home, you know.'

'Yeah nah. I get it.'

'Anyway, he won't be able to stop from laughing when we really are playing the Spark. When the girls really are checking out your undies.'

Faithful winked at his brother. 'Not girls, Bro. Women!'

REBECCA NASH

# The Wacky Waving Inflatable Tube Man

On the New World trolley bay,
there's a wacky waving inflatable tube man.
He dances with the Yacht Rock
blast from my tinny car speakers.
Each tubal gut wrench is a new beat
that lifts the song's sound.
Like a new-bongo-wielding bare-feeter
entering a drum circle
two tabs deep.

I drive around the block
to try him on Dolly, then Enya.
And around the block again to see how he moves
with the indie darling sweethearts
and the howlin' wolves.
Every time his twerk is perfect.
Its randomness like a spray of dust
in window light—
always, spatially, in time.

Beneath his body there is a wind machine
that blasts brain up
to sky.
If this were a movie, he would be about to go over the waterfall.
If this were a disaster, he would be a bird, about to be sucked
dead into an aeroplane propellor—
the inevitability of flow
the force of it.

I drive home,
past Christmas kitty biscuit tins
in op shop windows.
Past pylons red-tipped like cigarettes.

I open all the windows
for the wind.

NICOLA THORSTENSEN

## Church Picnic

That queasy, heat-haze afternoon
and you in no man's land between
child and woman.

Awkward in a silly frilly frock
one size too small,
you long to be anywhere else.

Faint guitar-strum draws you
away, conjures elusive shade,
surely just beyond those pines.

You sling your sandals over a shoulder,
soles delighting in cool grass,
but now a series of heart-carved images—

a slender girl wearing
your clothes, your face, is pinned, held,
unable to catch her breath.

Close-ups of oily pores,
sweat-swamped armpit,
the weave of his shirt

eyes wild
under the sun's glare,
and words, whispered words.

She cannot tell it.
Each word presses
on her chest, heavy as a tombstone.

SCOTT MENZIES

# Southend Special

Rob was sat at the bar of his local. November, a Saturday, nearly dinner time. A lad appeared next to him and asked the barman for real ale in an accent that wasn't English. Brave order for a foreigner. The lad pulled off his beanie and flattened cowlicks. His scarf flicked Rob as he took it off. Wool, it felt like. He put the scarf and his jacket over the vacant stool next to Rob and sat on them. His jeans were selvedge, by the turn-ups. Rob wasn't queer or nothing but the lad had fit legs—not football player like, but not skinny neither. He couldn't place the accent. The lad was white, like himself, but it wasn't Continental or American. He asked straight out, 'Where you from?'

The lad looked surprised. 'London.'

Was he taking the mick? 'Nah, mate. I mean where you *from*? Australia?'

The lad sat up straight. 'New Zealand.'

New Zealand. Well I never, Rob thought. He remembered the ads down the cinema. It looked like paradise.

The lad's hand trembled as he brought the ale slowly to his lips. To Rob's amusement, a flicker of distaste crossed his peach-fuzzed face.

Rob asked, 'Why come here? Why Southend?'

'I wanted to see the end of the river,' the lad said.

Father Thames. The estuary. Rob thought of the vast plain of sand and mud at low tide, of steel water and steel sky joint with lead solder of Kent, of Vikings in their ships, clinker-built, a dragon's head at their prow.

He gestured a half-circle. 'What do you think?'

The lad ran a finger around the rim of his glass.

'It's better in summer,' Rob said.

The lad laughed.

Rob liked both the laugh and the fact he caused it. 'Rob,' he said, and stuck his hand out.

The lad stuck his hand out too, warm and smooth. 'Jacob.'

'Student, are you?'

'I'm a project coordinator.'

'Yeah? I'm a welder.'

Jacob looked unimpressed.

Rob said, 'I've been to Norway and Spain.'

Jacob said, 'Oh, yeah?' He pulled out a phone and flipped through it.

That's it, Rob thought. The lad doesn't want to talk to an old git like me.

'I took some photos,' Jacob said.

Rob saw a selfie of Jacob on the pier. He took pride in the pier, not that he had been on it for years. 'Longest pleasure pier in the world, that is,' he said.

'I walked to the end and back,' Jacob said.

'Fuck me! Didn't you see the train?'

'Oh, yeah, but I was sweet walking.' He swiped through photos of the in-between, the sea-reach, the amusement park, some art, the Cliff Lift, the palm trees otherworldly in silver-light autumn; of lads on the parade, perched on rails, loitering loose-limbed outside the arcades.

'You gay?' Rob asked.

Jacob leaned back.

'Ain't no problem for me, son,' Rob said. 'More things in heaven an' earth.'

Jacob blushed. 'Am I that obvious?'

'I don't blame you. World famous for our good looks in Southend, ain't we?' Rob gestured at himself.

Jacob laughed.

'Shouldn't you be down The Cliff then?' Rob asked.

'I walked up it.'

'Not the cliffs. The Cliff. The gay boozer.'

'Is it good?'

Rob laughed. 'Not my kind of establishment, mate.'

Jacob's face flashed something. Disappointment, Rob decided. The lad's into me. He's into me and he's disappointed I ain't queer. 'Like I said, ain't no problem. You prefer straight pubs then?'

Jacob shrugged.

'How old are you?' Rob asked.

'Twenty-four.'

'Guess how old I am.'

Jacob studied him. 'Forties?'

'Forty-two. Wasting me time with that moisturiser!'
Jacob laughed.
After a while Rob nodded at Jacob's pint, which was still three-quarters full. 'You going to finish that? Let me get you one of what I'm having.'
'You don't have to.'
'That ain't fit for consumption. Have a lager.'
'Okay, thanks.'
Rob downed the last of his pint, signalled the barman and placed the order.
Over the fresh drinks and some chips, Rob felt a sense of ease and companionship he hadn't felt for a long time. Time flew. Around nine o'clock he decided if this lad could stare at his crotch and admit to being gay then he could say it. He'd never told another bloke before, not outside an anonymous chatroom, let alone revealed it outside his flat. He leaned toward Jacob and said, 'I dress up.'
'What?'
'I dress up.'
Jacob looked blank.
'I'm a TV.'
'A TV?'
'TV. A tranny. You know? Drag.'
Say something, Rob thought. Fucking say something.
Jacob asked, 'Like RuPaul?'
He'd have to show him. He could give the lad something for his wank bank, a Southend special. 'I'm off home after this,' he said. 'It's five minutes' walk.'

★

Rob shielded his eyes from the stair light as he floated up to his flat's door, buoyed by the sound of Jacob's footsteps behind him. He opened the door, flicked on the lights, adjusted the dimmer and drew the chintz curtains across the bay window, which, in the presence of the lad, felt thrillingly illicit.
'Come in, son,' he said as he took off his coat and hung it on the rack next to the door. '*Mi casa es su casa.*'
Jacob entered, closed the door behind him and looked around.

'I'll get us a beer,' Rob said. When he returned Jacob had taken off his beanie, scarf and jacket and put them over the back of a chair and was stood in the middle of the room next to the coffee table. He seemed startled. Was he a thief? Rob looked around. Everything seemed in order. The statuettes of Odin and Freya were at either end of the mantelpiece, the photo of the missus and the kids between them.

'Here,' he said and handed Jacob a can.

'Cheers.'

They cracked them open and both took a sip.

'Standing around like lost souls, ain't we?' Rob said.

Jacob laughed.

Rob took his usual half of the settee and took the remotes off the other. 'Come and sit down.'

Jacob's right knee knocked Rob's left one as he sat. 'Nice place,' he said. 'PlayStation.' He nodded at the controller on the coffee table.

'You play?' Rob asked.

'Not really.'

They sipped their beer.

'I'll stick some music on,' Rob said. He settled on something without words. 'That's more like it.'

Jacob sprang on him. He felt the lad's lips around his earlobe and his body pressed against his arm. Rob froze. Jacob's lips kissed his cheek. As they approached his mouth Rob turned his face away. He ain't queer. Jacob brought his left leg over Rob's thigh like a dog about to hump. For the first time, Rob felt the pressure of another bloke's hard-on. When he felt Jacob's hand on the inside of his thigh he pushed him back by his shoulder. 'Take it easy.'

'What?' Jacob asked.

Rob pulled his arm from between them. 'How 'bout I dress up now?'

Jacob shrugged.

'Yeah? I'll be back in a minute.' Rob stood up and went to the adjoining bedroom, closing the door behind him. Fuck me! He turned on the light and drew the curtain. He opened a dresser drawer. The babydolls were folded and stacked. He felt a spark of joy, took out his three favourites and placed them side by side on the bed. The drag queens were always doing it big, so perhaps

the sparkling diamantes. The light purple one was Rob's favourite, though. It wasn't just satin, it was luxe satin. That was the one.

He undressed down to his briefs and stepped into the babydoll, careful not to tread on it. As the material glided over his skin he shivered with pleasure. He adjusted the straps over his shoulders and did up the buttons. From another drawer he chose a black opaque sixty-denier pair of tights with a high-shine finish and put them on. Turning full circle in front of the mirror, he adjusted the straps and smoothed the hem. He shook his head, arms and legs like a footballer about to run on the pitch, then opened the door.

Jacob's eyes were a spotlight so bright Rob could barely see. He took a few paces forward. His face burned. He heard himself say, 'Luxe satin.' He sat on the settee, wondering if his pounding heart was visible through the fabric. Jacob took a sip from his can and then lunged at Rob as he had before. Again Rob's arm was trapped and again Jacob straddled his leg. Rob said, 'No.' He pushed Jacob back. 'What do you think?' he asked and gestured at himself.

'Yeah,' Jacob said.

Rob looked down at himself. Yeah? The luxe satin had a fainter lustre in the dim light, but lustre all the same. He loved the play of light and dark moving across the material as he breathed, especially in the pleats below the breast panels. He loved how the tights flattered the curves of his legs. Yeah? Was that all the lad could say?

Jacob's left hand crept under the babydoll's hem until it was hot against his chest. Rob was dumbstruck. He hadn't been touched like this for a long time. Then he worried it might stretch or dirty the luxe satin, elastane or no elastane. The lad was kissing his neck using his tongue and when Rob felt it go over a strap he worried saliva would stain it. He worried the tights would ladder. His arm was going numb.

Jacob's hand retreated from under the hem and he lifted his crotch from Rob's thigh and began fumbling with his buckle. Buckle undone, he started on the fly.

This ain't right, Rob thought. 'That's enough,' he said. He stood up. He's just a kid, he thought, a pissed kid. 'You can kip on the settee,' he said.

Jacob looked blank.

'Well?' Rob asked.

'What?' Jacob asked.

'You can kip on the settee.'

'I don't understand.'

'Don't understand what?'

'What you said.'

Fuck me. 'Kip'—Rob mimed a pillow against his cheek and pointed at the couch—'on the settee.'

Jacob looked either side of himself. Realisation dawned. 'Does it fold out?'

'No.'

Jacob glanced at the bedroom door.

Rob crossed his arms.

'I'll go,' Jacob said and stood up.

Rob grabbed Jacob's arm. 'Nah, mate. You don't have to.'

Jacob pulled himself free.

Rob felt like a fool. He looked at the babydoll over his belly. He wasn't having this. He wasn't fucking having it. He crossed his arms and glared at Jacob. 'Fuck off then,' he said.

'What?'

'Fuck off!'

As Jacob buttoned his fly and fastened his belt Rob grabbed the beanie, jacket and scarf from the chair and opened the flat door. The stair light flooded the room.

'You fucking off or ain't you?' Rob said.

'Can I ...' Jacob said and held out a hand.

Rob thrust his gear at him, seized him by the arm and propelled him onto the stairs. Jacob missed the first step and tipped. Rob lost his grip. As Jacob tumbled one of his feet knocked the wall, turning him, so he slid the rest of the way backwards and came to rest on the lower landing with a thud.

Rob went into the flat and shut the door. The missus and the kids smiled at him from the mantel.

MEGAN KITCHING

# Crematorium

What a word. So Victorian. Hygienic in the mouth.
     Open it like a nut, a decorous crack of the throat,
a hushed aspiration. Syllables roll like an asphalt road through
         the rounded o to the i,
               come to rest at the end, the em, the um.

Vowels buttoned down on a plush lawn. A lone
         cross against a bright blank sky.

CILLA MCQUEEN

# Deep South Survival Art

We watch our step—along this southern coast,
wild shore birds roost in their fabulous nests:

Approach with care the far-ranging de Wagt,
gliding back to her nest in Tuatapere
with a century's history of shape-shifting
world's wrack, plastic—this,
for instance, not an antique
long-stemmed ivory pipe, but a priceless
1950s sundae spoon of Tupperware—
wink of an eye, loads up a brush
with colours, flies out to paint the ocean;

Nor this a shipping container rusting
in the fields above Orepuki
but a miniature art gallery,
the inside of a telescope trained on the sea.
In sun-gold plumage the Sexton paints
in her New Zealand Railways red caboose,
enjoys the dual perspective of its windows
through which the guard can see the whole train
curving around the past and future track;

The Hill's smile curls like a wave,
his surfboards gracefully shaped
to part the water cleanly,
his Aparima nest hand made
of boat-parts, driftwood, iron, weathered timber,
interlinked and overflowing huts—

surfboards line the ceilings—
strewn with a sculptor's treasures,
resembles the cabin of a storm-tossed boat
after a rough passage through the Strait;

These wild birds seem to say what they mean
with their lives, tell the truth of the given,
beauty you wouldn't recognise until it's gone.

---

\* *The artists referred to in this poem are Janet de Wagt, Andrea Sexton and Wayne Hill*

MELODY NIXON

# Outbreak Narratives

*The line between science fiction and social reality is an optical illusion.*
—John Akomfrah, The Last Angel of History

**I.**
We fall asleep on our sadness, wake up with it stuck to the creases of our faces as the plane lands in San Francisco. Throughout the night sleep was broken by a harried cough, some sneezes.

★

The awkward, socially distanced run-walk through the airport to get to another gate, to find out if the international flight is still on. Are we going to be able to exit to there, or is this, here, our new reality? Staff in the airport, at the gate, scanning passengers, without protective gear.

A tweet by a British GP who warns of the shortage of personal protective gear for medical staff in the UK: 'We are like cannon fodder.' The frontline of this fight, the avant-garde. Airline ground staff, customer service agents, gig workers delivering food. Medical staff, nurses, nurses' aides, medical assistants, doctors.

That GP died five weeks into the pandemic.

★

Repeat after me:
*I refuse to lose my humanity. I have a choice to move towards calm and connection.*
*I will remain in the place where neurosis and fear do not take over. The mind feeds off fear.*

★

At the departure gate, an announcement: New Zealand closes its borders at midnight. It is unclear, in our socially distanced news-sharing confusion, whether the closure means no one can come in, or just non-citizens are

barred. A circle is being drawn here. Inside/outside. We are about to board our plane; we are the lucky last mixed-identity passengers that will make it through before the closure.

In the through-another-night flight the man in the row next to me coughs up sputum into a plastic cup. Cough, cough. Hoik. His face a bit rebellious, a look of just you try to stop me. The airline staff have to take his trash from him. Without protection. Me, and the passengers around me, rigid.

★

Landed. Disinfected. Avoided by locals in the airport, avoided by locals in the arrivals terminal. Disinfected to my quarantine accommodation.

Walks: furtive. Taken early morning or in the last rays of day. I am a virus-host among us. I contain my little cough. It's nothing. I breathe deeply into the congestion, because I can. I wait on Healthline for one hour and forty-five minutes to get instructions for my virus testing station.

★

I have a mask that a friend gave me before I left NYC. A coveted N-95, tight-fitting, it becomes my boundary and my signifier. Alien from New York, from the place where It Is Bad. Not above your detection but safe for you in the sunlight; there is a boundary over my mouth.

★

No sleeping, then sleeping, then no sleeping, because of the tightness in the chest. After the test, which returns negative, the congestion worsens. It cannot be THE virus. Another virus—or a false negative? Boundaries are erected between viruses, though the false negatives test them. The boundaries between days thin to translucent. Now seven whole something since I left. Now two weeks since this virus manifested in NYC.

The grief feeling is: I liked what we had before this. There were parts of what we had before this that I was starting to like. A lot of good just got cancelled.

An image of my apartment in upper Manhattan the day I left: unhooked bra over the back of my desk chair, birthday cards upright on my desk, some drawers half opened, the bed with the sheets I had been sleeping in.

★

My current circle is time. Repeating time, now time. But the Now Shape is not a centred, grounded bliss. Some periods between nights it is amorphous, some periods it is a straight, hard, unrelenting line. It moves on and on. Time is:
- I may not get to see you, or you, for another ten months. It is:
- More and more and more ends to lives. It is:
- And now the ends to lives are entering my circle:
    - My friend's older sister
    - My student's friend's dad
    - My almost-lover's friend's dad. Texts at a ten-person funeral
    - My friend's friend who was a doctor
- It is the cardiac arrests and the stress-induced deaths, more extensive than we know
- Parent fears
- The dear friend who is struggling to breathe right now
- Expanding, radiating lines.

★

News. Numbers snaking upwards with no hope of curve. We're in the middle of the uphill freefall, on an inverted slide. You thought north was up? Up is not north!

★

Repeat after me:
   *I own the mind. The mind does not own me. I can redirect my thoughts, I have ownership over my attention. The ruler of ME (in a healthy world) is the HEART. Not the mind, the mind is a tool to accomplish the aims of the heart.*
   *I have ownership over my mind.*
   Did you repeat it?

★

Subset (a subset being a thought inside another thought, a circle within another circle) (this one coming often on the once-a-day walk): the Aids crisis. Not the severity of the disease, but the presence of the unknown, potentially deadly, invisible. Bug-chasing parties in the 1980s—for some, not knowing whether you had the virus was worse than knowing you had it. So let's all get it. Give it to me. News about Covid-19-spreading parties, before people properly understand. Virus parties.

My recurring thought at the final social event I attend, 12 March 2020, NYC: It's like we're at a bug-chasing party and we don't know it. Our conscientious host: handing out rubbing alcohol and paper towels because there's no hand sanitiser left.

My friend, a poet: 'Oh … the virus is *among* us.'

That friend, now sick in Queens, NY. He says the chest pain is so, so bad.

⋆

I go out of my quarantine accommodation on the coastline at the very bottom of New Zealand's North Island. I look at the night sky and let the logical sentences fall away.

⋆

There is a lot for the mind to make of this. What are the (so many) violence(s) that come from thinking of ourselves as separate from nature? That is one thing we can ask. Human disconnection from the nonhuman as a violence caused by other violence(s), with industrial capitalism (urbanisation, factory farming, hyper—) a willing intermediary.

Pandemics arising often from the conditions of capitalism: overcrowding on farms in Kentucky (the 'Spanish' Flu); increasing commerce along the Silk Road (the Black Death). The bird and swine flus emerging from factory farming. Extracted animals.

In the social reality: the US government 'liberating' extractive industries from environmental regulations. The worsening of environmental conditions. This is not causal (of this pandemic) but it is hypocritical. A line drawn: nature, wildlife—not us.

⋆

The term anthropocene doesn't cut it, doesn't explain the interwebs we're in. Yes we are netted by science, medicine, history, culture, literature, economic drives, fossil fuels, consumption, pollution, geographic variation, political will and political practice. All of that. But yes we are netted by mould and microbe too, by companion species and climatic shifts, and by so many things beyond our scaly vision. We're netted by rock and by tree circle and sky overhead. Anthropocene as a gentrifying term.

Anthropocene as a terrifying term, if it disavows our full webs.

⋆

What might a nonhuman discourse of the coronavirus look like? Where we accept our cohabitation with it, embody our tentacles, reach them out, suction like?

★

So I want to know: who are the hosts of your life?

**II.**
Yesterday the rain arrived from across the bay, a grey, advancing sheet. It lay itself across this enclave in a long, wet hug. I went outside, jogged in the drizzle, came back with the cough.

★

Today marks my ten-year anniversary of arriving in the US as a permanent resident, a green-card holder, a resident alien. Time to celebrate! Except. I'm spending this anniversary teaching an online class from my quarantine accommodation in Breaker Bay, New Zealand.

Time keeps shifting—certain qualitative aspects to it, anyway. Time and distance. My students are in the following time zones:
- UTC
- EST
- CST
- PST
- UTC+8
- UTC+13.

We self-isolate together, communicating through the box that is now our classroom. We write: self-isolate. We aspire to self-empowerment, or rather: I aspire to empower the we to self-empowerment. We write: self-empower. We brainstorm each phrase. Isolation:
- island,
- *isola,*
- sea,
- milk,
- sea,
- froth,
- foam,

- barrier,
- porous,
- boundary.
- And: origin, power, human, autonomous
- At the end, across the Zoom platform (I despise Zoom the way I despise Instagram, Instacart. All of them profit from our distress)—at the end we look up, at each other. Fourteen faces.

I'm sorry, I say, but I couldn't get my books from the department office before it closed. I got some, but I don't have a scanner. I could have looked for e-copies online but I was worrying about my cough that was coming. So the syllabus is—well, it's fluid, flexible, constantly shifting; the syllabus has quarantined itself due to an abundance of caution.

I don't have enough paper to write notes on during class. I use the back of students' essays, still to be graded, that I stuffed into my suitcase in the hours waiting for my rental car slot to open, my evacuation rental car. I use the backs of the Borrowdirect tags from the library books I smuggled out of the country. When will they be due now?

'Your writing right now can be your safety. It can be your *open space*.'

'The sirens … how are the sirens there, in the city?'

'It's like … there's a constant threat.' *Threat*.

We all know the threat is invisible, and it is inside us. It is economic, and political, and spiritual, so it is also outside of us. Inside/outside: while reinforced by our physical quarantine, the division keeps collapsing. How do we *treat* it—both act towards and try to solve it? How do we do this when we so easily share, transmute, one molecule?

★

Subset, though: Alone meaning a lone, lone, lone, lonesome, meaning an island, *isola*. No one here but me, I without him/her/they. Hello. A lone body walks the orange sand inside. What a bitch that I am single. For the first time in ages.

★

Subset: self-reflection. A Week Two kind of thought: This is how life should be, anyway. Internal, reflective. I couldn't be with him because he didn't self-reflect. I couldn't self-reflect with him because there was a general

atmosphere of self-deflection. These days in quarantine, with him, would be filled with him playing video games on his phone. Drinking. Actively not thinking about the big holes that language can't cover—as if (as if!) they aren't the most important thing.

I want to at least aspire to breath, to breathe to self-reflection. To get halfway there sometimes. I don't want to drink a lot. I want to go to bed early. I am attracted to men and women who go to bed early.

★

He wakes me up at 3am with a drunk dial. No: I went to bed at 11pm and he phones when it is 3am where he is. I make a quick calculation and realise this. Drunk dial. Before I can consider whether I should answer, before the threat places its hands on my shoulders, he hangs up.

★

How do we 'be with' microbes? How do we exist alongside, and with an unwanted thing? Give it the space to breathe between us. Treat the threat not as a threat but as a being-together-with.

Or a sym-poiesis: making together with. Making together with, through the unease. Keep making.

★

Subset: dreamlessness. Fall asleep, wake up. What happened to the things in the middle?

★

Subset: snacks. Like fictions. What is a snack? How does one come by one? Are they appropriate, suitable for the morning?

★

Subset: fridge stocktake: One and a half cooked steaks. That's three whole meals. Word. Half a lettuce still. Three apples, three kiwifruit, an orange, and six medium-sized tomatoes. Chocolate: a treat. Three eggs, potential protein sources for three lunches! A whole, enormous eggplant. I still think my Italian friend who delivered that to my quarantine zone was suggesting something. There's no discretion to an eggplant in the time of smartphones. He delivered it with a note:

*Vuoi uscire con me fra 14 giorni?*
Si ___ No___
Will you go out with me in 14 days?
Yes ___ No___

Go out. Leave my self-isolation and go out into … into what?

Fourteen days of self-isolation because I am an alien, arriving in New Zealand from an infested planet. We aliens bring the disease with us. We must be hidden away. Given eggplants.

★

The storm closes in and grey, thick mist covers a band of rain over the ocean. The waves pick up. This is a southerly coming, I guess from Antarctica. The lower level. It's cold down there in the basement. Or up there. South is the reference point, the north now. And blustery. Here comes the storm, the swell, the storming.

★

Subset: Anne Frank's Diary. Reading it as a twelve-year-old (or eleven?) girl. The sexuality. The feelings of irritation, of anger, of frustration. Was it okay for a young girl to write those things? She seemed so mature! So brave! The sadness of the accruing number of days. I wanted to stop time for her. To reach back into her time arc and help her step out of it. The sense of young-girl impotence: terrible things happen, and you, YOU, can do nothing at all to stop them.

That was real confinement, real imprisonment, real solitude. With the threat of death more terrifying, embodied in human form like this one is, but with guns, with emotions, with the disambiguative sicknesses of human minds.

★

When a plague (they don't know what plague) struck Athens in Thucydides' day, Pericles ordered everyone to shelter within the city walls. They sheltered together as their technology. He died, along with up to 100,000 others. They brought the microbe within their circle.

Biosociality: a collective identity grounded in a 'shared, technoscientific, biological experience'. Biosocial circles that circumference. A hundred

thousand people inside city ramparts. Those who are fleeing an epidemic, maybe, but still carry it inside of them.

<center>*</center>

We cannot shelter ourselves away from something inside of us.

We are New Zealanders, or hybrids of some kind (Kiwi–American) coming from outside, other places. Some wanted the border closed to us too. Others thought that allowing our return, even facilitating it, was a national duty. The membrane remained porous for us; the microbes with the right identifiers returned to the cell.

National identity as a boundary that microbiopolitics always threatens.

## III.

Is ice-cream still a thing out there, outside of quarantine? Still a treat? A treatment?

Somehow thinking about ice-cream leads me to think about grandparents: those who did not have ice-cream. The reproductive, ice-cream-less place we result from. The until time.

Grandparents lived through the Second World War and the Great Depression. Just them. Then time on earth reproduced itself into something relatively peaceful for the rich countries, for the colonisers. Often there in my mind's eye. Grandparent/coloniser. Farmers. Thiftily beavering away.

But to portray them that way (in peaceful times): only a part of the circle.

<center>*</center>

The microbes enter and live with, and through. We eat them, we breathe and imbibe and absorb them. *Ninety percent of our body matter is microbes.* Any politics we discuss is made of the mould from the borders of cheese, of yoghurt, of dirt traces on zucchini.

Microbiopolitics are the power relations between human and nonhuman biological agents, and the ways these relations are situated in the human body. We can't go beyond the body. We are always drawn back to the body. And the body is not even ours. We are hosts, a conglomerate of organisms, a walking anthill of microbes shape-shifting as we imbibe, eat, breathe and reproduce in our different ways.

Posthumanism as the place the Western academy has turned to theorise

our ailing now, and our impossible future. Perspectives on the human situated outside of the human self. Nature gazes at human, we think, and we channel it. We try to collapse the subject-object we are so wired into.

★

Posthumanism is a colonial project; like my grandparents farming New Zealand, putting *the cows on the land in fences*. Now we theorise about what the cows we fenced in are thinking.

★

Perspective and meaning-making have been situated in animals, in trees, rocks, plants, in the nonhuman world in indigenous knowledge systems well before this current moment. Posthumanism and the anthropocene: trying to claim themselves as the centre, regardless of where they are situated. Not even thinking about opening the farm gate.

Perhaps the colonial subject, wired in subjecthood, claims herself as centre regardless of where she is situated. NYC. New Zealand. Perhaps her mind can do nothing but that.

★

At times I feel the centre of this circle is not coalescing, but is doing just the opposite. Maybe it is just wider than my field of vision, wider than my grasp of metaphysics, wider than any field of energy I can tap into. Maybe it extends out and loops around to the beginning of humans.

★

An almost-lover I had just met in NYC before the evacuation texts that he dreamed of us in stars—or him in me, with the stars overhead—while he is there in the US and I in New Zealand.

With the widest perspective the islands here are being reclaimed by the sea; they are washing into something smoother. All I can say with the borders closed and time already thick is that so too maybe the night sky works on us, while we sleep.

RUTH ARNISON

# Winter Calls

This morning I spent bedside on the chemo ward,
tissue wiping trickle tears before they cascaded
over her chin.

'Talk,' she said.
I spoke of second-hand clothing purchases, first-hand poems,
elderly fathers and overdue books. There was no future
in our language, we conversed in the present tense.

After,
I wandered through the Botanic Garden, kicking
autumn skywards, listening to cool-throated birds practising
their repertoire—winter calls.

RUTH CORKILL

# Ecology 221

I spent one summer measuring
two metres by two metres

in leaf litter and rocks and moss.
Two metre by two metre

sections to keep in mind
and patiently itemise

organism by organism
in a tally chart that kept

sprouting columns
as we found unforeseen species;

ribbed lime-green bracken leaves
crown ferns, hen and chickens,

bracket fungus even once
the impossible cobalt flesh of

a something mushroom.
At the time I knew their names

in triplet English Latin te reo Māori.
Now I find it hard to look

for long while standing
and difficult to settle on one

two-metre-squared sample.
But I tell myself this drought has made

the banks less lush.
The mosses, stubbornly waiting for rain,

feel more like cotton nylon than velvet.

CLAIRE ORCHARD

# Our son of eighteen summers

put our Toyota of ten
under the back of a bus
at the Basin Reserve
the afternoon of the day
we flew to Dunedin.

That night he called
while we were eating steak
and drinking wine
and his voice explained:

the bus stopped dead
while I was checking
my blind spot.
Then the cops (who happened
to be passing) stopped too,

wrote me a ticket,
while all the passengers
got off and walked away
in different directions.

JUSTINE WHITFIELD

# Bathrooms of New Orleans

**Bathroom 1**
At the entrance to the Greyhound station restrooms in New Orleans, a yellow A-frame sign says 'Cleaning in Progress'. I have no idea how long the bus journey to Baton Rouge will be. I'm worried that if I don't go now, I will end up desperate on the bus. I hear the male cleaner singing in the women's bathrooms to the left and make a snap decision. I dart past the yellow sign and into the men's bathrooms on the right. I close the stall door quietly, lift my dress, lower my underwear and begin to pee.

The singing becomes a little louder.

'*Rock the Casbah. Rock the Casbah.*'

And then louder again.

'*Sharee-ee-eef don't like it. Rock the Casbah.*'

And then I hear the metal bucket clang down on the tiles outside my door. So close that I can also hear the slap of the water re-levelling in the bucket.

'*Rock the Casb*—Hey! What are you doing in here?' Not quite a yell, but something more than song volume. 'That sign says *Closed*, clear as day.'

'I'm sorry,' I call, still mid-pee although my muscles have now locked off the flow.

'The cleaning is for your own protection. It's about hygiene.'

'I'm so sorry. My bus is about to go …'

'Hey! You've got an accent. Where are you from?' No mention of my gender. Perhaps my voice is unisex.

'New Zealand.'

'No way. Kiwi-bird land, right?' He whistles and laughs. 'Those birds that don't fly.' More laughter.

'And those other guys. Wait, wait, don't tell me. Frodo and Gandalf! Yeah! My daughter's a fan.'

I let my muscles go. Pee rushes into the stainless-steel bowl.

'Yup, some of the filming was done near my home.'

'Which scenes?'

I angle on the seat, trying to pee sideways onto the stainless steel to lessen the sound. 'Umm, Mount Owen, I think. The bit where they come out of the Mines of Moria.'

'Yeah? Is that so? Well hey, this is really nice. Welcome. I hope you've had a fine time in this city. I'm going to leave you to your peace for a moment.'

I had had a fine time in New Orleans. On Friday I got smashed on Hurricanes at Pat O'Brien's bar. Part of the reason I drank so much was that I still had another two weeks to spend in the swamps of Louisiana with my colleagues Simon and Hannah and the other gun-toting, pickup-driving fantasists our company employed. The carpark at corporate headquarters was a wash of oversized vehicles driven by men in beige pants and collared business shirts. Christian family men feeding wives and kids off the Mexican Gulf oil and signalling their strength with bull-barred trucks, subliminal code for domination of the land and all of the beasts that walk upon it.

I'd eaten bright red crawfish and popcorned alligator with these men, my fingers cracking small shell backs and my face wet with butter grease, because I wanted to be gracious, wanted to fit in and was too embarrassed to admit I was a vegetarian because there was a condescending supremacist vibe inside vegetarianism if you knew where to look.

Those men would not look there. They wouldn't walk so deep into unploughed fields of thought but I was conscious of the chink in vegetarianism. Not eating meat out of compassion for animals was based on a notion that human beings are a different class of life, 'other' to the animals. Or, if we accepted ourselves as part of the animal realm, we vegetarians thought we were a better kind of animal. We were the animals who condoned animal-ness in other species but could rise above it ourselves.

In truth I was comfortable with people eating meat if they had looked the animal in the eye and caught it with their own claws. But I didn't view guns with long-distance sighting scopes as claws. They're a tool and yes, for sure, there is that thing about chimpanzees being observed using sticks to scrape ants from a hollow log, and for sure that's an example of animals using tools, but a stick is not a gun, no matter what the vigilante parents of Montessori preschool children say. Don't get me started on Montessori parents.

Anyway, if I wasn't going to talk compassion with these men, the alternative was to say I didn't eat meat out of concern for the planet. Industrial farming and excess consumption and all that. But that was not a

field of unploughed thought. That was just a shallow cornfield and these men who worked in oilfield aviation services would walk into it at a moment's notice with floodlights and hero complexes and GPS-enabled tracker drones to rescue anyone lost in such young green stalks of delusion.

**Bathroom 2**
That's the thing about toilets, I find. Everything is let go. People are reduced. Momentarily real and out of role. The day before, in the hotel lobby, a young man, a wedding guest in a blue velvet jacket with a pink peony buttonhole, was trying to open a bathroom door. He asked me if I could try my access card because his wasn't working.

As I swiped my card he said, 'I'm not trying to get you to come into the bathroom with me.' And then he said, as I got the door open for him, 'But ma'am, you're still real good for your age and all.'

All this in a flash of less than a minute.

★

Montessori parents. I just can't leave it alone now. The parents who want brightness for their children send them to Montessori for early childhood education. Maria Montessori was an Italian educator who believed education should be child-led. Interests are inherent within the individual and both the individual and society are enriched if a child engages fully in learning. The individual maximises their own creative potential and emotional wellbeing and, in turn, is a constructive social presence, more likely to contribute innovatively in their fields of interest.

Excellence and innovation lead us forward as a species, provided the path we are on is beneficial to society. Where a path is not beneficial, engaged individuals are more likely to have the critical powers to detect the dangers on the existing track or highlight the alternative bridleway. To call out in the darkness. Full engagement is enabled by allowing the individual to follow the interests that lie inherently within them.

This idea has parallels in bio-dynamic farming. Land systems flourish when each life form is permitted to exist in its natural state, and in the symphony of diversity the complications of one are compensated for by the predilections of another. Wholeness found within the collective presence.

The irony comes later, when I see a Montessori child being shepherded

toward a traditionally prestigious career. A child naturally interested in medicine or law should not need to be shepherded. And a parent secure in their own truth should not need to shepherd. A child's career trajectory is not a status symbol. The counter to this, of course, is that a child who does not need to struggle for money will have a better chance at happiness. The shepherd is both an altruist and a realist: cares for the sheep but understands the lies of the land.

## Bathroom 3

It started several cocktails in. Simon appeared beside us wearing a set of reflective purple beads over his button-collared T-shirt. He said a man gave them to him in the bathroom, that people throw the beads from the carnival floats at women flashing their breasts. Hannah and I approached a group at the jukebox, admired their beads and managed to return with strands of our own. Mine were silver-mirrored and larger-globed than Simon's tiny raspberry string. From there, Simon suggested the competition.

I didn't want to. I hate anything win or lose but he was my boss and there was no graceful way out. I divide the world into people who understand sport and people who understand art. Simon and Hannah understand sport. In their presence I feel like a large fluffy rabbit. Not a biologically real rabbit but a soft stuffed toy. Pink with dirty spittle marks and a frayed grey ribbon at the neck. A symbol of the comfort required by those who are weak and useless in the corporate setting.

Hannah, Simon and I had arrived in Houston just five days before, en route to headquarters in Lafayette. We sat in an airport restaurant and ordered beer and tacos. I cleared an email from a member of my team and explained to Simon that Rose was hospitalised for an intravenous feed of antibiotics, ill from toxins in her system, but working from her bed in an effort to meet her month-end deadlines.

'She's always sick,' he said.

'My partner also has Crohns Disease,' I offered, 'and these abscesses Rose has are part of the disease.'

'There's a difference,' he said, 'between a person who is fit and motivated and someone who is a fat lazy git.'

Hannah laughed.

For this and a thousand reasons of the exact same theme, I didn't say no to the competition to acquire beads from strangers.

## Bathroom 4

Out in the street I stood in the mild night among the milling groups of people. It was nice to be alone, invisible in the fret, everybody assuming I belonged to somebody else. I had twelve strings of beads by now. I leaned for a moment against the wall. I hate people really. I get so drained from speaking and smiling, all the knee-jerk warmth that I pump at them because I feel like I can feel the unsureness behind their talking front-wall faces.

A small man in a black New Orleans Saints cap leaned beside me, shoulder height. He wore a nylon bomber jacket that hung mid-thigh on him, and three strings of the largest beads I had seen. One set of white plastic pearls and two of a shiny metallic ebony.

'Tell me about the beads,' I said.

'These?' He stretched them out like a triangle between his neck and two thumbs. 'I just found them on a fence when I was walking.'

'Somebody inside said that people throw them for women flashing their breasts.'

'No no, that's a tourist thing. We hate that. It's not the real Mardi Gras. The real thing is that they get thrown from the floats in the parade and people catch them and wear them and, you know, it's all part of the excitement.'

And then I don't really know what happened but he told me about his daughter who was having a baby and that he was sixty-three and lived on a war pension and was saving money to get to the state where his daughter lived and we slid further down the wall and sat on our arses on the pavement watching people's feet and calves and he said how his disability came from the Gulf War, damage to the nerve endings in his spine, and that there had been oil wells on fire that other men had seen but not him, how he had just eaten breakfast one day, oat biscuits and coffee because he wasn't real hungry, and then an hour later was caught in a jeep that slid off the terrain. Just like that. His world entirely changed but everything else stayed as it always was.

And then he said, 'You have kind eyes,' and I knew that I was safe but I was frightened too because I didn't know what it was that had made me leave my group and open myself so intensely to a stranger and I was vowing to myself,

all over again, to just be normal and to learn to patrol my boundaries better, but still I kissed my index and middle fingers, the ones I'd use to make a gun if I was a kid, and daubed them onto his cheeks, left side, right side, like I was a pope, and I smiled and he smiled back and we stood up and he yelled to the bouncer, 'Hey, Caleb, let this lady back inside,' because we saw a queue had formed. And he gave me his three strings of beads. And I gave him three loose dollars from my pocket.

And despite the renewal of my eternal vow to mimic normal better, or perhaps because of it and in recognition of this latest breach, I went upstairs, freaked and rattled, and in the bathroom I behaved like an apologetic white person, which is to say a racist, and I don't say this to apologise but to own the shit I trip on and to say to any other apologetic white person that there is a time when your voice doesn't count and all that you can do is stand aside and open up the crawl of your innards for others to inspect.

*

She was perhaps twenty-five and offered me toilet paper and hand towels in a small cane basket. On one side there were coins and dollar bills and I understood that I needed to tip. And then I understood that this was how she made her living, standing in a bathroom in a nice white cotton dress while patrons partied in adjoining bar rooms and outdoor courtyards and on gracious iron fretworked balconies. I took a tissue and towel and tipped her, did what I needed to do and left. But then, in my freaked and rattled state, I went back with more money and asked if this was her job and if work was hard to come by.

And then I truly lost it and asked if her life was okay and I knew immediately that I had done wrong. That the extremity of my reaction was based not only on the obscenity of someone trying to make a living passing paper products to people who have surplus cash to drop on booze, but on the respective colour of our skins. That although her presence in this role had roots in socioeconomic inequity, those roots were rooted in colour and I'd broached the unspoken too directly.

I went back downstairs and sat on a bar stool. Like a toddler in time out, I thought about myself. I drank a glass of water. I couldn't decide if it was the implication that perhaps some people enjoyed being served this way in bathrooms or the needlessness of the service that upset me more. The social

structure which meant that she was forced to trade her time for money by offering a non-essential service for which people paid from some space of unconfronted apology. And the speed of the transaction allowed them not to confront it. They could drop a dollar in a basket and be done.

**Bathroom 5**
In the hotel lobby Simon said goodnight to me and Hannah in front of a plinth that held a giant golden urn full of stemmed white lilies and yellow roses. He shook my hand and said, 'Congratulations, winner,' and then reached the other wavering hand toward my chest, his fingers formed in a pincer grip. He lifted away several strings of my beads, halving my haul, and put them over Hannah's head. I wanted to say, 'I thought you hated socialism. What right do you have to tax my efforts? It wasn't luck that got me these.' But I didn't because in those days he was still my boss.

 The next morning we bought tickets for the tourist loop bus at a corner store. My stomach gurgled. I'd got out of bed determined to prove that I could sleep off four Hurricanes and an unknown number of pre-made margaritas in just six hours, and walked with Simon and Hannah to a breakfast joint. But in the ticket shop the shakiness behind my waistband made me nervous.

 'Is there a public bathroom nearby?' I asked the man.

 'Sure, sure,' he smiled. 'It's not really public but I'm gonna let you use it.'

 'Maybe use the civic ones at the river walk,' Simon whispered.

 I stepped through a curtain into a room with a sink and cardboard cartons and a dented pale blue fridge. Light was falling from a window in the ceiling onto the cracks in the tiled floor. The man indicated a grey painted door to the left and said, 'The light doesn't work. You'll need to leave the door open.'

 I listened to his footsteps shuffle away and pushed the door almost completely to. In the crack of light that remained, I saw a large dead cockroach lying on the floor. The shadowed fuzz of its upward-facing feet reminded me of a threadbare toothbrush. I wondered what else might be crawling inside the unilluminated corners of the room. When I was a child my mother would get into bed with me in the middle of the night when I was scared.

 'It's not the dark that frightens you,' she said. 'It's what's inside it.'

 I tried to forget she'd said that.

ELIZABETH SMITHER

# Port Hills, Canterbury

Never such a violent declension
or shortage of words for it.
Not 'magnificent', far more slippery
as they tread with giant steps through gorse
or peer over a road they've made perilous

but on their edges softer trees, ridiculously small
try to pacify these giants with bibs
and smaller still, the close-placed cherry trees
signal like fairy lights and declaim their liturgy.
*Hope, hope, hope* along the edges.

CONOR CLARKE

# As Far as the Eye Can Reach

1. Piha (described by Paul Brown).
2. Piha (described by Paul Brown), detail. Courtesy of Two Rooms Gallery.
   Photograph: Sam Hartnett
3. The sky over Colombus (described by Shawn Lowe).
4. Lake Kaniere (described by Lewis Smith).
5. Parnell Rose Garden (described by Rhonda Comins).
6. University Oval Cricket Field (described by Mark Flowerday).
7. University Oval Cricket Field (described by Mark Flowerday), detail.
   Courtesy of Two Rooms Gallery. Photograph: Sam Hartnett
8. Huka Falls (described by Steve Delaney).

All 2020, C-print with Braille (PVC, UV ink), 980 x 790mm

This series was made in collaboration with members of the blind and low vision community in Aotearoa New Zealand. Each work begins with a description of an outdoor experience as it was recalled to the artist. The description can be read in braille on the surface of its photograph, or listened to via audio narration through attached QR codes.

—Conor Clarke

SOPHIA WILSON

# Brown

The river is brown.                                         Our feet are dirty.
   Summer   draws         beads of sweat                    from pebbles.

When I queue at the dairy,      women I do not know              share tales
relating to lumps and aches.       There is a new physician,       *Foreign*—

(apparently)                                        they will not  be seeing him.
They are nodding.       Understanding one another.           I also nod,

politely, smile and pay              I carry a cardboard tray—hokey-pokey
ice-cream in cones—to half-caste passengers strapped in child seats.

Quietly, we disappear     to our isolation            of paddocks and gorse.

At night, when the children sleep,      and their father returns, weary,
I will not mention     what the people think                        of him.

DAVID EGGLETON

# Sawmill Empire

The history shut up in the book
of a tree opens out in the shape
of a house that sways like a stout
three-master far out at sea.
The aboreal lifts from its foundations.
Between dripping leaves the trees
become hundreds of stairwells
and eaves that lead up to the stars.
Remove an eave when it gets stuck;
it's stripped back to its bare frame,
carved up and trucked off to a lifestyle block.
I am, sang the frame of the house.

Trees were living ancestors
transformed for a bush town,
an enchanted settlement,
while through the cleared canopy
glided the sky, all the way
to the corrugated-iron steeple.
A tracery of wrought-iron sprouted
vines and grapes, mazes and spirals;
friezes filled with quatrefoils, rows of teardrops.
Forest gone to villa, to second-hand
store, to student flat, to antique
shop, to millionaires' row.
From moon-white night, an axe cuts shadow.

Deep-verandahed summer was a sounding-box
of rocking chair, cradle creak, piano notes.
Fretworked and embellished corridors led
to tree stumps and level ground; a door knob
turned for a tea-tray and a spoon's rattle.
Floorboards pressed their tongue and groove;
joists creaked their backs, bending slightly.
Rivers washed up brownish,
sluiced with bark tannins and clays,
or were a silvery arm-wrestle through bracelets
of gravel below the arches of branches,
fluted balustrades, cast-iron sunrises.

Tree-houses are barged out of swamp,
and a pole house rises through tree tops
like a moa bird getting above itself;
but some crave eminences to rise from,
so crank dwellings up, and bring them
to headlands, and lower them there,
frail box-kites balanced precariously.
Left to face demolition are elderly tea-rooms,
timber that once ran straight and true,
now warped planks, clapped-out, bored-through:
wood rotted to punk and dust.
Go map the place, lift the blindfold;
touch cross-cut saw, handsaw, jack plane,
smooth plane, brace and set of bits;
trace lost aromas of resin and sap.

The night waltz of houses on the move,
the dancing skeletons of a weekend retreat:
houses shifted on the backs of trucks
to create a new town further around the mountain.
Boards span the air; a drive of logs
funnels along a flume;

the weatherboard city,
lifted from its blocks and piles,
travelling in the wee hours of the morning,
is tunnelling through dreams
into the back country,
where reception committees of iwi
await with taiaha and haka.

HAYDEN PYKE

# Ostrich

When was the last time we saw the sun
was it before this, or after you got parole
I used to hope that light would pierce
the flat of my hand, the concrete
has long given up getting warm and
time has shattered against the sky
waiting doesn't mean anything anymore
maybe when you screamed I have
my head in the sand, this is what you meant.

MEDB CHARLETON

# Dear Life

From a sapling you flamed
like a peacock in the September sun,

light illustrating in your leaves myriad
venous tracks.

Once feathery, spirited things,
they started taking off like crows' wings.

Your apples emerged, not fully formed,
hung on through a late summer storm,

but fell, still shy of grown,
a day before the cold arrived,

turning the earth
cardinal red and gold.

In my sleep stories I wait for their return,
time travellers from the dark churn,

and I wake, hear gulls in early hours,
then descend myriad venous tracks to the sea

among marram grasses,
swimming in the breeze.

OLLY CLIFTON

# Giant Soldier Man

The giant soldier man arrived on a Sunday afternoon. At first I thought there might be a street parade going on. The soldier was lying on the back of a flatbed truck, so from a distance it looked like some kind of grotesque float. I sat there watching out the window laughing smugly to myself. What a hassle, moving that thing. And who was still protesting *war*? At least actual physical, hand-to-hand combat with bayonets and that. Wasn't it all drones and trade embargos these days?

But my chuckling ceased when the truck stopped right outside our house. A man with a clipboard got out, walked across the street and up the steps to our front door. He knocked and I answered.

'Are you Jo?'

'No, but she lives here.'

'She in?'

'Back in a couple of hours. Can I help?'

'Yeah, can you sign this please.'

I took the clipboard. I wanted to read what it said but the man held his hand out expectantly so I just signed the bottom and gave it straight back.

'Cool, where shall I put it then?' He stepped sideways into the garden and turned around with his hands on his hips.

'What?' I said.

'The giant soldier man.'

'That belongs to us?'

'To Jo.'

I frowned.

He gave me a stern look. 'The museum waived the delivery fee on the agreement that she would take it.'

'Well, I didn't agree.'

'Well, *she* did. Look, I'm gonna have to leave it here.'

'But where are you going to put it?' I walked towards him in the garden and

we looked at where his truck was parked. The sculpture of the reclining soldier had to be at least six or seven metres across and a couple high.

'It's Jo's property now. Either you tell me where you want it or I just leave it in a carpark on the street.'

'Hang on, I'll ring her.' I turned back inside but the delivery man stopped me.

'Look, mate, I'm in a hurry. I've got some old taxidermy shit to drop off as well. How about I just chuck it in the garden over there?'

I stood in the doorway and finished my cup of tea as he used the crane on his truck to lift the giant soldier over the fence and into our garden. There was just enough room to place it between the house and the washing line but the soldier's massive thighs crushed the lavender bush.

*

The exhibition had a bunch of these oversized fibreglass army men, sculpted into a number of positions, each one more tragic and arresting than the last. Jo had selected the last in the set: the most dramatic. A soldier fallen on his side, gripping his abdomen with his left hand, a bloodstain creeping over his khaki shirt. In his right hand he held a revolver, aiming it desperately at some invisible assailant, his mouth open in a half-snarl, half-scream.

I assumed this man had been mortally wounded and was trying to avenge himself in his dying moments. Which seemed like an odd thing to do. If I were shot and about to die, I suspect I'd be so obsessed with my own mortality that I'd be unlikely to attempt murder. But who knows—maybe this man wasn't doomed. Or maybe he was defending a fallen comrade. Perhaps he saw every enemy death as a win for whatever he thought he was defending. Maybe people act strange when they're in that amount of pain. I reminded myself that it was only a sculpture—perhaps it was all in the artist's mind and no one ever actually spent their last moments gritting their teeth and emptying their ammunition into the middle distance.

I sat with the giant soldier all afternoon, beneath his massive head, staring over his massive nose into his massive eyes. I thought about my great-grandfather who had died in the war. Tried to feel some of the sadness my mum had reported on her visit to the exhibition. But I couldn't find it anywhere inside me. Instead I just felt a little embarrassed. If I died, I don't think I'd want an effigy produced of me in my final moments. Screaming,

covered in dirt and my own bodily fluids. Not that I expected to die so dramatically, but still.

It got cold after a while but I didn't want to stop looking at him. I thought that if I got closer I might feel something more profound. I lay down under his gun-holding arm so that my head was positioned directly beneath his and looked straight up at his chin.

When Jo got home she found me lying there.

'Yes!' She ran over and stroked his artificial hair. 'Isn't he good?'

'Jo ... what are we going to do with this?'

'Sell it.' She kept looking at the sculpture. Running her hands over all the different materials his clothes were made of.

'Who's going to buy it?'

'Are you kidding?'

'No, are you?'

'Look at it!' she said. 'It's massive!'

'Yeah, exactly.'

'What's your problem?' She turned towards me.

I crawled out from beneath the head. 'Who's going to want a sculpture this big?'

She shrugged. 'Someone will. I did. People loved that exhibition.'

'Yeah, I like ... trams ... but it doesn't mean I'd want one rusting away in my garden.'

'Wouldn't you?'

Well, maybe I would. 'You know what I mean. How'd you get this anyway?'

'The exhibition finished and they didn't have enough storage space.' She shrugged again. 'I said I'd take it.'

'Did anyone else take one?'

'Just me,' she said. 'They dumped the rest.'

'See? How are we going to flip it if no one even wanted one for free?'

She looked at me like I was stupid. 'It's the only one left. It's more *valuable* now.'

<center>*</center>

We put the giant soldier man on TradeMe, then spent the afternoon lounging around in his shade. A few people walked by and took pictures of us over the fence. I worried they might use the photos for some kind of flimsy visual

metaphor: the giant man literally using his body to protect us (civilians) against the sun (fascists?).

I didn't like the thought of that so when the next person walked past and whipped out their phone I considered trying to stop them. But I didn't. Given the soldier's overbearing presence on the street, I felt the locals had a right to a souvenir.

About an hour before the sun was due to go down I noticed some rainclouds off in the distance and pointed them out to Jo.

'Think we could get him inside?' She leaned against the soldier's leg and squinted into the distance.

'Doubt it,' I said. 'Anyway, I don't really care what happens to him.'

Jo shot me an annoyed look. 'Come on. We can't let him melt in the rain.'

I shrugged. 'There's no room, even if we could get him through the door!'

'How are we gonna sell him if he's all droopy and wet?'

'Jo, there's been like three views on the auction. Can't we just chuck him out?'

Jo shook her head. 'No way! It'd cost a fortune at the landfill.'

I sat back down and leaned against the soldier's chest. I wanted to tell Jo that this had been a stupid idea and I wanted nothing to do with it. But that wouldn't get us anywhere. I knew that whatever happened would be a two-person job.

We ended up running down to the hardware shop and buying a heap of tarpaulins. We strung the blue sheets between the roof of our house and the washing line, creating a lean-to structure that covered the soldier's length. Just as we finished stringing up the last of the blue sheets the rain started coming down. Our structure was barely adequate. It protected him from overhead, but he was still being lashed in the sides by rain catching in the strong wind.

Jo swore and ran inside for towels.

'You mind the front,' she said, passing me a towel and heading around his back.

'What—are we just going to keep wiping him down?'

'Yeah, until the rain stops.'

'We could be here for hours.'

'Come on,' she said, 'we'll halve whatever we get for him.'

'Jo, we're not going to get *anything* for him. And we could be here all night.'

'Come *on*,' she said urgently, eyeing the rainclouds. 'Doesn't look like it'll last too long. And someone'll offer us something for him tomorrow. I'm sure of it.'

<center>*</center>

It did last too long. The rain went on until midnight. We crouched there for hours wiping away the droplets as they gathered on his bloody torso. If I didn't wipe the water away fast enough the wound on his chest would start to glisten. At my most exhausted I became convinced I could smell the blood. Some of the rain found his face too, gathering on his forehead like sweat, pooling in the dents beneath his eyes until it dropped to the ground in oversized teardrops.

The next day there were a few bemused comments on the auction and a couple of new watchers, but no real promising activity. And it turned out the previous night's rain was a harbinger for a week of really bad weather. It rained for at least half the day every day for the next seven. Jo called in sick to the museum all week so that she could look after the soldier. I don't know if she bothered to calculate how much money she might make from selling this thing against the money lost from not working—but again, I didn't say anything. Fortunately—for Jo—I was working from home and could dash out and help whenever it started to rain again. To her credit, Jo was very thankful and repeatedly insisted I'd receive half the profits from the sale.

The week of bad weather ended with a Saturday and Sunday of nonstop rain. When she saw the forecast on Friday Jo freaked out. That morning she'd seen water coming out of the soldier's knee and suspected he was absorbing some of the rain. He wouldn't last much longer. We ran through a number of solutions that afternoon and settled on the first one we thought of. The simplest.

Jo knew the sculptures were hollow inside so we made an incision through the soldier's uniform and into his back. The stuff the sculptor had used to replicate the skin was made of a thick silicon, which was pulled over a fibreglass frame. Without badly damaging the soldier we thought we could stretch the silicon back and remove a chunk of fibreglass to make enough of a

gap to see inside. As soon as the blade went in, water poured out. We shone a light in and realised there was a lot more water in there than we thought, pooling in his hollow groin and legs. We widened the gap to run right the way along the soldier's spine. Now it was big enough to climb through.

Jo went in with a mug and started bailing out cupfuls of water. There was only room for one so I stayed on the outside towelling him off until the rain stopped. We went to bed early that night, setting our alarms for the morning, just before more rain was due.

*

It poured all day Saturday, then stopped for a few hours during which we slept. It started again very early Sunday morning. That day I must have spent about fifteen hours towelling while Jo lay inside bailing him out. Without breaks. If we paused we'd just have to work harder to stop him getting soaked again. Eventually my legs gave out and I had to sit down and rest against his bloody torso. I closed my eyes for a second and immediately fell asleep.

When I woke it was brilliantly sunny. I must have been out for a while because the soldier was almost completely dry.

I walked around the back looking for Jo and was immediately blinded by a barrage of flashing lights. A crowd had gathered on the street, staring into our garden. Someone had even removed some fence pickets so they could see better. They were all taking photos.

For a moment I felt like a celebrity. Imagined I was in a white bathrobe, sunglasses, hung over—just popping out to collect the paper. I straightened up and stared at the mob with my hands on my hips. Another wave of flashing and clicks. I cleared my throat and was about to ask them all what they wanted when I heard a noise from behind me.

I turned and saw Jo's hand coming out of the slot in the soldier. She must have fallen asleep too. I pulled aside the flaps of uniform to help her slide herself through the opening. As we were doing so, the photographers started shouting at us. We froze.

One of them stepped forward.

'Oi! Stay still!' he said, elbowing someone else out of the way as he moved his camera tripod. Another wave of light. Jo and I both covered our eyes.

'What are you all doing?' I shouted at the crowd.

'What are *you* doing?' a bunch of them shouted back at once.

Jo and I looked at each other. What *were* we doing? She was sitting on the edge of the slot we'd cut, half in, half out of the soldier. I took a few steps back and admired the frame. To be fair to the pushy photographers, it was quite a shot. I turned towards them.

'Stop!' I shouted.

'Why?' they called out in chorus.

'Please!' I said.

Their shutters kept snapping.

'Move out the way so we can see the girl properly!' one shouted.

I looked at Jo. She still looked half asleep and was squinting through her hands at the flashing lights. I couldn't figure out why I was so annoyed. I think I just didn't want to be in the news. I reached for the nearest bit of tarpaulin, pulling it down to cover the back of the soldier, and Jo too.

The photographers all made disappointed noises and shouted at me to remove it.

'Give you fifty bucks for a photo with the girl in it!' someone shouted.

'Leave us alone!' I shouted back.

'Hang on,' said Jo, jabbing me in the side. 'A hundred!' she shouted at the photographer.

'Yeah, all right.' He reached for his wallet.

The other photographers reached for theirs.

⋆

I must have gathered the levy from at least twenty of them. Those who didn't have the cash borrowed it from others or bartered with what possesions they had on their person. After a few minutes my pockets were bulging with cash, IOUs scrawled on the backs of business cards, a couple of Casio watches. Someone even gave me an expensive-looking belt. I put the tarpaulin back in place and Jo climbed inside the soldier.

She seemed to find it quite entertaining, and did a number of fun poses as the cameras flashed. I felt incredibly proud. I wondered if these photographs would make it anywhere notable. Newspapers. Magazines. TV. Art galleries. Maybe even a museum.

RICHARD VON STURMER

# Mona Lisa

I bought a jigsaw puzzle of *Mona Lisa* for five dollars at a second-hand shop. The reproduction was yellowish and several pieces were missing. While doing the puzzle I was drawn not to her eyes or smile, but to the delicate fingers of her right hand, slightly spread apart and resting on her left forearm. I noted that her hands were warmer in colour than her face, as if she had been washing clothes next door before coming in to sit for Leonardo.

NATHANIEL CALHOUN

# Bhutan

we bunched together
posturing in dispute about
how visitors should be processed
through our loosely held territories:
growth versus it's-good-enough-already
yachts versus hitchhikers.
more was okay, multitudes not so much.

the consultant asked a question
to which the answer was Bhutan.
so I guess we can restrict
access to whatever we want.

DIANE COMER

# Son, Sword, Chocolate

Dark out, almost winter, I'm driving my thirteen-year-old son to the train station. Only a handful of trains run in New Zealand now, but seven trains run each day from the West Coast, bringing the cleanest-burning coal on earth to ship to China to make things none of us need. The long spine of the Alpine fault with its young mountains divides the dry, flat, profitable plains from the wet, forested, impoverished west. But this is not about geography; this is about my son going on school camp.

    I don't go on camp as parent help, nor did my mother. I was sent to camp and expected to cope. I did, or did not—which? But I'm driving my son at o-dark thirty, as my dad used to call it, to be on time. We're early, so early I'd like to find a place for coffee. Outside a strip-mall café a woman sets chairs out on the patio, never mind it is northern hemispheric December. The barista bristles at our American nerve for wanting coffee before they open, but says yes, give me five minutes.

    My son notes the coffee machine's Italian. A red, shiny, baby Ferrari hissing steam. My latté and his hot chocolate arrive, a fern leaf etched in the foam. Venice isn't part of Italy, or even Europe, he says. Venice is its own place. He's been there. He reads. Elaborates on Venetian maritime power and then launches into chocolate. The problem with chocolate in New Zealand is there's only two kinds, and they're essentially the same. He shrugs in disdain, the way young men shrug their shoulders and throw off father, mother, chocolate, world history in one motion. That tower, he points to an ugly squat concrete tower near the train station, it had possibility, but the colour and texture are all wrong. His handsome face is blossoming in blemishes and I feel my heart contract as we sit in this empty strip-mall café in Christchurch, New Zealand, at 7am. The marshmallows melt against the rim of his cup and he leaves them.

    We go back to the car. I'm tired. He didn't have to wake me, and I know he's grateful for that. We drive to the parking lot outside the train station.

Girls, he says, are smarter in class but not overall. I'm too tired to argue. The swords are wrong in *Braveheart*. You only use that blade on horseback—it's too long if you're on the ground. He snorts. He's young and weird, but in a good way. What do sons think of their mothers? I don't know and yet I can read every flicker of doubt or disappointment, the sudden flame of joy, because his emotional face is mine. I often think of William Maxwell asking what it means to be too sensitive when there's so much to be sensitive to.

My son sits beside me in the car, not talking but present. The radio is crap and we veto that. Still dark. Are you ready to go? He gives me a look that says I'll leave when I'm ready, when only minutes ago he's spoken volubly about Venice, chocolate, swords and the relative intelligence between genders. I don't know him, never mind he came out of my body. He's wearing my black merino pullover, is several inches taller than me, and I don't know him. Yet if through some horror he came back from camp in pieces, I would recognise even a single finger. The first thing I looked at when he was born was his beautiful newborn hands.

When he is finally ready to leave the warmth of the car, the silent radio, he grabs his pack and book, ducks his head under mine and lets me kiss his forehead. His sudden smile breaks through, startling as sunlight caught in a mirror. He walks away, the loose, easy gait of his father's family, all cowboys, all solitary males, sauntering off without looking back, but you know they love you.

MICHAEL HALL

## Something Ends

Silence
sits eternal in the sun
and is there

until
the end of the world
and afterwards

there is a wreckage
of silence
around that beautiful star

and not all distance
is far away
as Kierkegaard might have said

ANTONIA SMITH

# Never Been to San Francisco

I have never been to San Francisco but I live in Newtown / all night the desperate humming of the helicopter to the great concrete hospital / yawning of ambulances in the frenzied clarity of night / totally at odds with long-term accommodation motels like stagnant aquariums / all silt-drudged lodgers are stunned fish looking out at the street with wide fisheyes / there is glass here / one man / out of the slipstream / with head out the window above out into the currents / rivets in the air left by people going places people in the slipstream / and with my bus stopped at a red light another walks out onto the road / he has a lollipop in his hand and he is looking at me out onto the road / to tap against my window leaving oil slick sugary smear / we are across from Hospital Confectionery and he has left me a message he knows what he is doing because I understand / I understand and I will write about it later / all the tyre shops slumped stubbornly shoulders to the street art / surfaces like the slick coat of a duck there is no purchase for paint here / a thousand handsewn languages all looping inward fraying so that loose ends can be caught passing by and dragged along the footpath / we go to the industrial laundromat / some just scream against shop corners and instructions like hieroglyphics these are truly lost just temporal testaments / our scratched-out back yard with a large tree stump a gravel slope to the road where bees waver between stalks of grass view of back doors and always the rocky hospital rising above always awake / and so many butterflies / she wants 20 dollars I'm sorry I say I am just on my way to the laundromat okay she says and stays where she is / a stack of sinking circles like a snowman in a blue jumpsuit like an artefact but she is a human and the helicopter hovering is a question the backdrop to a distinct dream but there are people inside / inside outside of the slipstream all along Riddiford Street tipping upward at each end / all the buildings toppling like ruined steps / off they go towards the hills / towards the port

SEBASTIEN WOOLF

# [queens]

Five days on the open
road takes its toll; distant
music dies on my ear
—caught in a landslide.

My darkest, saddest hours
lie ahead. Even the wicked
have nightmares, down in
Zanzibar with Farrokh.

Rumours spread like lyrics,
You say *bark*, I say *bite*,
Is it possible to be part-time
gay?—the place my mind goes

—crazy little thing.

ISABEL HAARHAUS

# Games

Nana knew the girl wasn't Rory's. Moreover, she knew that he knew. And yet he kept her around, favoured her even. She reminded him of her mother, Nana figured, and it was true: she was just like Tash—little slut.

Now they were all in with the old woman: her big lump of a grown son and his two useless children, neither of whom was his. One adopted and a loser, and the other a bastard, and working it at that. She was too dark and too lithe to be a Rafferty. Too fast.

For the sake of Rory, whom she loved despite everything, and her own peace, Nana kept it up; although all the girls knew too and that made her defensive.

'That young one at Dot's, always doing her dancing in the lounge, *she's* pretty,' they'd say, putting the knife in as women well can.

Melissa had a habit of moving all the furniture to get the whole *Flashdance* sequence in.

'Dad!' she'd call, squinting her eyes in impatience. She was quite sneery and called often, and Dad would heave in to see, smiling indulgently, happy to see her, keeping her near.

When Melissa lived in the house she shared Nana's room. It was small and sunny in the afternoons, with thick mustard-coloured carpet. The two of them slept in a double bed covered in a faded yellow towelling spread. There was a white dresser and Nana kept a pack of menthol cigarettes in the top middle draw. Flies got trapped between the glass top and the cabinet it covered. When she could be bothered, Nana rearranged the doilies to keep them out of sight.

Everyone smoked in that house, and in the sunroom by the kitchen, around the big built-in table, the old women sat nursing their warm, weak gins, playing bridge and chaining it. A grapefruit tree grew outside, branches scratching the open window, and there were loquats, passionfruit and feijoas.

The house stood on a flat section on the edge of town near the bottom of Hospital Hill.

Even though there was not often a meal there, the kids gravitated towards the Raffertys', and sometimes Nana did make tea—mince on toast, mashed bananas on toast, chips and Marmite sandwiches, or just a big pot of corn—but mostly the kitchen sat empty and dark at the back of the house. The cupboards, built deep for preserves and other stores, also sat mostly empty and were a good hiding place during the many hide-and-seek games the children played.

One of the cupboards—the one that connected the kitchen to the sunroom—did have stuff in it. Nana and them kept their supplies in it: bottles of gin, matches, cartons of cigarettes, bonds and raffle tickets, crossword pages, packs of cards, old TV guides, and occasionally packets of gingernuts or loaves of thick-cut white bread.

When Melissa first taught her new friend 'go-home, stay-home' she mimed the aim of the game, because Ruth had only just come from Holland and could not yet speak English. Melissa's brother Darby and his friends were impatient with the girl and called her 'Dutch Duck', but Melissa was fiercely protective of her friend. She already loved Ruth with the same cut of passion she felt for the horses tied up too short, even though the Dutch girl blushed easily and was useless at throwing and catching balls.

Ever since they officially became best friends the two girls were inseparable at school, and Melissa defended Ruth from the hidings she had attracted since she first arrived. Lately they had pretty much been left alone actually, except for the flurries when they all surrounded the girl from overseas, pointing at parts of their bodies so that she could name them in Dutch: *oor, bein, mond*.

Now that they were training for interclub swimming, Ruth stayed three nights a week with Melissa—either at Nana's or at her mum's—and was getting used to the games and their rules: 'go-home, stay-home', bullrush, knucklebones and sometimes cricket—although Ruth reddened at even the idea of a bat-ball sport and preferred to watch and practise her gymnastics instead. (Going upside down was a good way to get out of things.) Her English was improving fast because it had to, and she did like the freedom and all the kids at Missy's Nana's house.

Sometimes the girls peeled off and went roller-skating or swam in the school pool, climbing over the fence to get in and competing at holding their breath while swimming underwater lengths. They were so competitive that often they almost fainted from the lack of oxygen while swimming hard, climbing out dizzy with pins and needles behind their eyes, unable to see properly for nearly a minute.

Ruth loved the steamy smell and slap and peel of their wet togs on the hot rough concrete. Everything was rough here. The pool was cracked in parts and the paint was peeling off the edge and the rusty fence rattled as they stole over it.

This time they were playing 'go-home, stay-home' late into the day, after dinner time—although there had been no dinner because Nana and her lot were on it. Four old ladies at the table with their oily glasses, their ciggies, cards and sugar sandwiches. The kids knew not to bother them and got organised outside. It was big enough here, all of it: the weatherboard houses, the high pale sky with a few loose strands of cloud folded into it here and there, the dry yellow lawns, the length of the days.

By now Ruth knew the rules. You had to try to get back to base in order to free anyone who had been found, while the person who was 'in' had to both look for the others and protect the base, which was by the grapefruit tree, at the town end of the property.

One of Darby's mates, Joseph, was in, and Chris and Buzz were playing as well as the two girls. The boys were probably stoned, judging by the moronic looks on their faces and their delayed reactions while setting up the game. They were about three years older than the girls, and rangy. Ruth understood that you find your place and hide and stay quiet, and then, if you want to try to win favour, you risk your own freedom to try and free someone sent to base.

During the counting Ruth stole into the kitchen and crawled into one of the big cupboards, which smelt of mice and some kind of mothballs or bait. She almost squashed a carton of cigarettes and was tempted to eat a slice of bread from the loaf she felt in the corner. She was hungry. It was only when the door clicked shut that Ruth realised she could not open it from the inside and that it was pitch dark. But she could hear the women on the other side of the divide, laughing and murmuring in the language she could not yet guess at.

Crouching and slowing her breathing, Ruth remembered the darkroom her father had made in the laundry in their house in Holland. It seemed like a sort of dream, another life, but it was only about a year ago. She and her brother used to go in there with their glow toys: his a figure from *Star Wars*, hers a doll with bluish hair and starry wings that shone in the dark. They had not been allowed in there, and the smell of chemicals and the pictures of their beautiful dead mother hanging along the strings held a rush of illicit excitement.

But now she could smell rodents, a sharp poisonous smell, and dirt. Then she heard the click of the door to the cupboard beside hers: someone else had crawled in. It was one of the boys.

'Eh?' he whispered, as if expecting someone to be in there. Ruth heard Nana giggle and sensed the women turning towards the cupboard doors. There was an uproar of laughter, then the game resumed.

Which one was it? She didn't know but he came and sat close—too close—so that she could smell his grotty pot-breath. It was jagged, like his movements. He had been running and they were both trembling. He inched closer still.

'Ay,' he said, feeling for her arm, and then he grabbed her hand with his sweaty one and pressed it against his jeans. It was his crotch. Ruth felt the heat and his lumpiness. She did know about this but had never been near it, had never felt it. Now gripping her wrist, he forced her hand up and down and with his other hand felt for her, crowding and pressing into her whole body, breathing heavily. She struggled and sort of fell, her foot trapped beneath his thigh. It was so dark. She could hear the women and smell the cigarettes. He stuffed her fist into his pants. The boy was gupping now, trying to find her mouth with his, grasping and rubbing, doglike. She felt a pulse and then wetness on her knuckles.

Ruth regained her orientation and tore herself towards the small slit of light, pushing against one of the doors that opened onto the sunroom. She spilled out onto the card players' floor, Darby falling out on top of her. They were tangled and flushed. Her hand was still inside his pants, his mouth was covered in dry white spit and he was panting. Then he grinned. The women shrieked with laughter as Ruth struggled up and walked out.

In Nana's room later that night Ruth thought about telling her best friend

what had happened in the cupboard, but instead she suggested they take a menthol and smoke it. Melissa would be angry. She hated dramas that didn't involve her. Plus she and Darby had something between them, Ruth was sure. They knew they could 'do it', that they wouldn't have 'retards'.

That night Ruth slept in her jeans and had a nightmarish dream about being chased throughout a game of 'go-home, stay-home', in which she kept risking her freedom to release those captured at the base.

OWEN BULLOCK

# Bubbles

They brought Bubbles home and he was bleeding on a rug
he died later and I didn't see him
the family of a girl from school ran him over on Gunneath Hill
my brother said we should hate her after that but I couldn't
we didn't have any more dogs
no puppies like Tozer with a round head
father gave him away and drowned the others in a bucket but I didn't watch
we only had a cat, part wild, called Cat
or Tom
he was ginger and we sometimes didn't see him for two weeks
he was a brilliant hunter and he left rabbits with no heads on the doorstep
and father cut the end of his tail off when he slammed the sliding door of the
    living room
accidentally
he lived a long time

WES LEE

# University

At the window
the beautiful day.
*The day so beautiful*
what can you do with it.
What have you ever been
able to do with it.
And you remember Kapil Tiwari
describing the beauty
of a flower,
how we can never possess.
He'd crumpled imaginary
petals between his fingers.
And the solidity of a table,
he'd knocked on it hard,
trying to show First Years
reality is a construct
and in this shared room
things would only exist
and nothing could be possessed
and nothing was
how it was named.

FERGUS PORTEOUS

# My Octopus Teacher

The morning sun beams in through the apartment windows.

'Did you tell your therapist about our fight?' I ask.

'I mentioned it,' Kate replies.

'I hope you told her the full story.'

She smiles, leaning forward to depress the coffee plunger. 'Don't you worry about what I told her. It might surprise you, but we don't actually talk about you as much as you might imagine—I do have other things going on, you know.'

She pours the coffee evenly between two mugs on a footstool between us.

'What do you talk about then?'

She thinks for a moment.

'We sit in silence a lot of the time.'

She seems like she's going to say something more but she stops. Out the window a distant tower crane is silhouetted by the glare from the sun on the Hauraki Gulf. Halfway up the tower I can see the shape of the driver slowly climbing the ladder to begin the day's work.

'Does she give you advice?'

Kate bats a fly away from her face.

'She can be quite pragmatic. We talk about my needs. Setting up boundaries, removing blame, that sort of thing.'

I nod, interested.

Kate had started seeing the therapist some months prior. Although I feign indifference, I am obsessed with finding out what her therapist thinks about me, or rather, what her therapist thinks about the version of me that Kate has described. I never ask the question directly but try to lead Kate gently into sharing information. She has intuited my curiosity and now wields the information over me as a type of secret power. Whenever I broach the subject she deflects, and has reached the point that she will only speak of her therapist in riddles, which achieves the desired effect of exacerbating my frustration.

The trouble with disputes in romantic relationships, I have come to realise, is that neither party ever has an objective understanding of the other's behaviour. Both parties are prevented from seeing the relationship dynamic as it would appear to an objective observer, by their self-interested subjectivity. Case in point: Kate regularly informs me that I am an arsehole. I am willing to accept that this is true, up to a point. But when her criticisms cross a certain threshold, I find myself becoming defensive. My ego demands that I disregard her critique on the grounds that it is too strongly affected by illegitimate considerations—old resentments, jealousy or whatever.

I am aware that this threshold is largely arbitrary, and as much affected by the same illegitimate concerns that I impute to her critique of me, but with no external body available to adjudicate our disputes I am bound to trust my own judgement when things get a bit raw.

As a reflexive person, I know that in trying to undermine Kate's assessment of me by putting my own case back to her I may be engaging in what is colloquially known as 'gaslighting', but there is only so much beating my ego can take. I have to retain some belief in my inner goodness or I might jump off a bridge. And to take the contrary position, who is to say that Kate is not gaslighting me, inflating minor transgressions to set me up as the bad guy when really, as I suspect, I am a generally nice person who slips up from time to time?

Kate now has the benefit of a kind of neutral observer, her therapist, though the level of neutrality is questionable, given that she only ever hears Kate's views. My curiosity about Kate's therapy, if that is the right word for it, is born of the fear that Kate's resentful depictions, to which I am given no right of rebuttal, are taken at face value. I imagine her therapist nodding and clicking her tongue in that practised and professional manner, sending Kate back to relitigate our petty disputes with a sense of moral vindication. As an adjunct, I find myself inexplicably obsessed with the thought of a third party (the therapist) thinking badly of me. The thought fills me with anxiety, and I find myself obsessing over the content of these weekly sessions, from which Kate returns with an undeniable serenity.

'What does she look like?' I ask.

Kate narrows her eyes.

'Why does that matter?'

'It doesn't. It occurred to me I've never heard you say anything about her appearance.'

Kate looks out the window.

'I'm not asking in a sexist way. I'm just interested. I'd definitely ask if it was a man, too.'

Kate turns and rests her head on her arm on the back of the sofa. She fixes my gaze.

'What does she look like in your mind?'

I think for a moment, imagining the various exchanges that Kate has described to me.

'I get this sort of "open receptacle" vibe,' I say.

Kate smiles. 'Yes. That's exactly what she looks like: an open receptacle.'

I ponder this for a moment, then, sensing I am not getting anywhere, I change the subject, pointing at the distant crane.

'I wonder if they have a toilet in the crane or whether they shit in a bucket or something?'

Kate shrugs and sips her coffee. I stretch my hands and let out a hiss of air through my lips.

'Open receptacle isn't a physical description, though. It's more of a concept.'

'You said it, not me.'

'Just tell me what she looks like.'

Kate holds her coffee in her lap and smiles, leaning back on the arm of the sofa. 'What do you see when you hear the words "open receptacle"?' she asks.

She seems to have picked up this form of reflective interrogation from her therapist. I think for a moment, turning the words over in my mind. I am struck by an image of my teacher from Standard Two, Mrs Murphy: voluptuous and kind. She had a large soft face, doe eyes and frizzy red hair. Mrs Murphy was always very attentive to me. She used to reward my good behaviour with smothering hugs, enveloping my little body in her enormous bosom. She told me I should be a writer.

'Sort of maternal, I guess?'

Kate turns to look at me, eyebrows raised.

'Maternal … really?' She shakes her head, clicking her tongue softly. 'Oh boy.'

I catch the innuendo and convulse slightly.

'Not in a Freudian way,' I say quickly. 'I mean because she's a good listener, you know.'

Kate looks back out the window.

'You misunderstood me,' I say. 'I meant in the sense of caring and kind.'

'Whatever,' she says. 'You've said it now. I hope you write about this.'

We fall into silence. In the distance the crane begins to turn slowly, lifting a large crate of scaffold tube. A long strop dangles in the morning air like a gymnastic ribbon.

'Did you think that was a sexist question?' I ask.

Kate thinks for a moment.

'Yes,' she says abruptly.

'I don't want to write stuff that makes me look sexist.'

Kate turns and looks me in the eyes, dead serious.

'You have to tell it like it is,' she says. 'You *were* sexist. You claim to write about truth.'

I rub my chin with my hand.

'I really didn't mean it in the way you think,' I say.

'Actually, I think you did. You're just upset that I noticed.'

She leans back, bringing her coffee up to her lips. 'You only ever speak truthfully when you don't intend to.'

'Is that something your therapist said about me?' I ask quickly.

Kate sighs.

'It might come as a surprise to you, Fergus, but I came up with that all on my own.'

⋆

I find Albert on the internet. I type in 'Lacanian Psychoanalysts NZ' and he is top of the list. I call him, hoping he will convince me I need help. He doesn't sound very interested. He can see me, he says, he has a very full schedule but says he can fit me in. He gives me a bank account number, payment to be made in advance. I ask him whether he can give me a rundown on psychoanalysis before I commit.

'We will cover that during the first session,' he says.

We meet on Zoom. He has soft brown hair, tired eyes, olive skin—he's Peruvian. He asks me about my life and sits there making notes and nodding.

Whenever I stop speaking he propels me on with open-ended questions about my feelings. He tells me I'm doing very well, which I like, but in general he doesn't offer much. He seems most concerned with keeping me talking.

He asks me about my dreams so I have started writing them down. Kate thinks they are hilarious when I let her read them.

'You're so predictable,' she says, laughing.

In one dream, Kate and I are at a dinner party. I overhear a friend say something about male worker ants. (This friend has a PhD in biochemistry.)

'Incorrect,' I say, walking into the conversation. 'Worker ants are all female.'

He laughs in my face.

'Pretty sure they are male,' he says. 'Who do you think impregnates the queen?'

'Male ants have wings,' I say. 'They fly around looking for females to mate with.'

The Doctor of Philosophy laughs again.

'Male ants have wings?' he says, incredulous.

His laughter spreads among the group; Kate is laughing at me too.

'You're all wrong,' I say. 'It's the same with bees.'

'The same with bees?' he says. 'You've lost it.'

The laughter intensifies. The man's eyes are wide and his mouth hangs open—the group is jeering and laughing. Some of them shake their heads at me.

I plead my case but it's no use.

We sit down to dinner. While the conversation moves on I borrow Kate's phone and look up ants on Wikipedia.

'Look,' I say, pointing at the phone. *'Colonies consist of various castes of sterile, wingless females, most of which are workers, as well as soldiers and other specialised groups.'*

But the group has moved on. They don't care about ants any more. The man with the PhD plays it down, nodding wisely, as though pleased to learn a new fact.

'Huh, interesting,' he says.

'Yes, it is,' I say, looking around the table. 'Very interesting.'

★

I stand alone in the pantry, phone pressed to my ear, staring at the label on a jar of Marmite, imagining the tasty black sludge melting into a slice of toast.

'Have you seen *My Octopus Teacher*?' Kate asks.

'I don't know what that is.'

'It's going wild on Netflix; you're bound to hear about it.'

'Oh yeah, any good?'

'It's all right. It's probably the breakup, but I found it very affecting. I cried all the way through.'

'What's it about?' I ask.

Holding the phone between my ear and my shoulder, I carry the Marmite and the bread from the pantry and drop them on the bench beside the toaster. I unscrew the lid.

'What are you doing? Are you making food? This might be the last conversation you and I are ever going to have—you'd better not be.'

'I'm not making food. I'm listening.'

I put the lid down and step away from the bench.

'Sorry,' she says softly. 'I wouldn't put it past you.'

'Please go on, I want to hear about the octopus.'

'Well, it's pretty cheesy but it's a doco about this scuba-diver. His wife left him or something so he starts swimming this reef every day. He's a total creep, but he finds this octopus on the reef and it's so beautiful. At first she's scared of him but he keeps going back there every day for like a year and eventually she starts to trust him. I know you hate octopuses but she's kind of lovely, really: she can change colour, shape, texture, and everything. And she's clever, she's really good at hunting: she hides from predators by sucking up shells and rocks with her tentacles and pulling them around her into a globe, protecting herself like a hedgehog. And there's this bit where she's got six tentacles splayed around her like a skirt and then she uses her other two like feet to walk along the sea floor.'

'Oh yeah, sounds terrifying.'

'It's actually so cute—she sits on the guy's stomach and he pets her like a cat.'

I shudder quietly to myself at the thought of a tentacled alien attaching itself to my torso with its giant squishy brain bobbling away, horizontal pupils staring, and its awful beak hidden away in the zenith of its many legs.

'I'm sure it's charming but that sounds horrendous.'
'I knew you'd say that. Do you want me to go on?'
'Sure.'
'So the octopus lives in this little den where it hides from the pyjama sharks—'
'Pyjama sharks,' I repeat. I'm staring at the Marmite again.
'Yeah, they've got stripes like pyjamas. Anyway, one day the octopus is too far from its den and it gets attacked by these sharks, and one of them manages to bite off one of her tentacles.'

Kate pauses. I can hear her breathing.

'Are you okay?'
'I'm fine. Like I said, it's not even that good a film—it's just with everything going on, you know.'

She draws in a breath.

'So, she loses a tentacle but manages to escape by spraying ink and gets back to her den. And she's like so close to dying, it's so, so sad—she goes completely white and just lies there. The guy brings her mussels because she can't go out to get food.'

Kate stops talking and blows her nose.

'And then the loveliest thing happens: she starts to grow a new tentacle. At first it's tiny, but perfectly formed, this miniature little arm …'

She blows her nose again.

'… He keeps nursing her and feeding her, and the tentacle grows, and it takes forever but eventually she fully recovers.'
'Oh yeah, sounds really nice.'

There is a long pause. When Kate speaks again her voice is hard, metallic.

'Yeah, well, like I said, it's pretty light stuff, really, but it affected me, and I've figured out why. Would you like me to tell you?'
'Sure.'
'It's not particularly deep but, in the story, I'm the octopus, and you've taken my tentacle. I'm in agonising pain right now but I'm going to hibernate, and it will take me a really, really, long time but eventually I'll grow a new one, and it'll be better than before because I'll have dealt with it and moved on. I'll be stronger because of it.'

She lets out a joyless laugh.

'But *you*—you aren't suffering any pain because you're an idiot. You're just going to patch your old life with new friends who don't know how much of a selfish person you are, and you'll go on making the same mistakes over and over until you're old and bitter and nobody likes you.'

I lean against the bench letting my eyes unfocus on the Marmite. I try to really feel the weight of the words but I have the strange sense that I won't be able to.

'And chances are, like always, you will continue to be happy, you will always find people who like you and think you are special. But know this: it won't be a pure happiness like mine. You will always be chasing a false love. You will go on existing as a big black hole, sucking up everyone's praise and love and giving nothing back.'

The words hang in the air and I contemplate my fate. I search my bowels for some sort of reaction to this revelation but there is just a dull emptiness—not emotion, but a glaucous vision of the lack of it, a kind of apathy.

'Yeah, well I guess that's a fear of mine,' I say hollowly.

'And the funniest part is that you have a paralysing fear of octopuses. And now I get it.'

'Why's that?' I ask flatly.

'They're smart. You can't understand them or control them—you can't understand them, so you turn your lack of knowledge into fear and hatred.'

I hold the phone to my ear. 'You're pretty clever.'

'And you hate me for it.'

'But I don't hate you, though.' I feel my chest tighten up.

'You should be paying me instead of Albert,' she says.

I let out a sudden laugh and to my surprise, a tear drops down my cheek.

'Fuck you're a cunt,' I say.

Kate laughs. We sit in silence for a few moments.

'I hope you realise that I am quite literally in pain.'

'I'm sorry.'

'Like fuck you are. If you were truly sorry, we would still be together.'

I take a deep breath and blow the air out through my mouth.

'I think you're intentionally trying to sabotage my future relationships.'

'I might be. Is it working?'

'I don't know. Maybe. I guess I won't know for a while.'

She exhales heavily.

'I really need to go to bed.'

'Me too.'

There is a long pause.

'I guess this is it.'

'I guess so.'

I hear the sound of traffic through the hiss of the phone line.

'I love you, Kate.'

I cough, blinking.

'Goodbye, Fergus.'

I take the phone away from my ear. The screen shows: 'Kate (Wife): 02:14:32.'

I tap the little red circle and the timer is replaced by the words 'Call ending ...', which dissolves into my lock screen.

HAYLEY RATA HEYES

# Air-bridge

Light sings
across the building's
block façade

silenced
here and there
by tree shadow falling.

American white ash
touch each other
branch tip

to branch tip,
as they stretch
across the road.

They form an air-bridge bond,
a gentle enclosure
limiting the limitless sky.

On this weathered bench
feel wood grain
through gauzy trousers

held and suspended
above the bricked-shut
earth.

Think: How worn you've become
and what it took
to get here.

E WEN WONG

# My parents on why we are not in the phonebook

My surname means yellow
like the yellow pages on my skin
Covid-19 alerts corrupted
in an alleyway of Chinese whispers
tirades of bat-eating, wet-market-blaming
vectors of disease.

In class I write my name on a yellow page.
Year 13 History is turmeric soup
diluted with milk of colour and the colour is white.
We read an exemplar on the Chinese poll tax
like it's an extract from *Winnie-the-Pooh*
noting its well-crafted phrases
with our plastic yellow highlighters.

My family volunteer each year
at the Yellow Pages fundraiser
for the table tennis stadium on Blenheim Road
where ching chong ping pong champions
are *actually decent human beings*
'cos *we've lived most of our lives here.*
We drop phonebooks in letterboxes
and wait for the calls, children on the line
asking whether we eat dogs.

At the dinner table
we discuss the attack and hospitalisation
of a Japanese boy
in the neighbourhood we once lived in.
My parents tell me
this is why
we are not in the phonebook.

It has been years since we
opted out of the phonebook
years of silence to the sinophobic categorisation
of the good normal migrants and the others
yet somehow we retain the paper cuts
yellow pages slicing our skin
and the black ink
harmless letters and numbers
bleeding onto our fingertips.

ZINA SWANSON

1. Stunt (Pointing at a daffodil will keep it from blooming), 2020, acrylic on canvas, 35 x 25cm. Courtesy of the artist & Sumer, Tauranga
2. Imagined wood with leaf flames (Burn wood and the flames will form themselves into the shapes of the leaves of the trees from which the wood came), 2020, watercolour and acrylic on canvas, 30 x 25cm. Courtesy of the artist & Sumer, Tauranga
3. Sticks I Have Thought Of (Five of too many), 2020, watercolour and acrylic on canvas, 25.5 x 46cm. Private collection
4. All My Sticks Have Auras (Ground - Pink, Radiating - Violet), 2021, watercolour on canvas, 50 x 35cm, Private collection
5. All My Sticks Have Auras (Ground - Yellow, Radiating - Green), 2021, watercolour on canvas, 40 x 30cm. Private collection
6. All My Sticks Have Auras (Ground - Yellow, Radiating - Green), 2021, watercolour on canvas, 30 x 25cm. Private collection
7. All My Sticks Have Auras (Ground - Pink, Radiating - Pink), 2021, watercolour on canvas, 45 x 30cm. Private collection
8. All My Sticks Have Auras (Ground - Blue, Radiating - Purple), 2021, watercolour on canvas, 30 x 25cm. Private collection

All photographs: Sumer, Tauranga

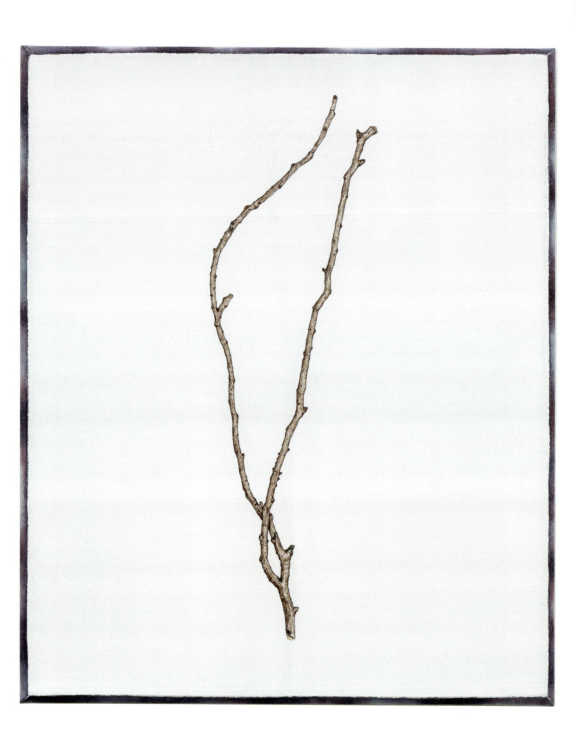

ANNA REED

# Sirens, Stop

It's 4am on the medical ward and someone dies in bed 19. Sirens, sirens, sirens, stop.

I know lots of people who carry grief in their hands. Rosie has grief carved on both arms. She's breathless, here on furosemide. My children visit and I cry when they leave, little pictures of stars and glitter on my bed. That night the staff turn off the lights and Rosie appears in the curtain, steeped in glitter. What a beautiful red-haired boy, she says, so lucky.

Rosie tells me about her three babies, all boys, all born at home. Each boy died a year after the other, her arms swinging between full and empty. Her daughter was born in the hospital, this one. She's still here, Rosie says, her sons strung on her arms like little beads.

Oh, Rosie says, her voice heavy. I'll tell you about them sometime.

Rosie's daughter dutifully brings in lunch every day. Chicken, salad. Chocolate brownie. Rosie squeezes her hand. Grief sits beside them, on top of the white sheets, quietly and well behaved.

Do you remember my boys? Rosie asks her.

Tell me about them, her daughter answers patiently, making space in the bed for her brothers.

When the sirens stop on bed 19, the doctors leave respectfully.

Rosie's daughter says she's with the boys now.

She undresses her mother's bed, unfolds her cradling arms.

TREVOR HAYES

## Ultrasound

Sometimes we are nothing
but the souls of our feet.

We are an echo location in a safe haven
waiting for a new atmosphere.

We are lines of descent. Our heads
have crowns, illuminated. These bones

are not hollow despite their birdlike
conjurations. The mystery is

who you are. Without knowing any better
we thank the higher frequency and wait.

MARY MACPHERSON

# a swarm of dots

'you've got bee poo on your windows'
says the man whose men will come with poles

and a special solution to try (and fail) to wash spots
from old glass. The wind on the Mahia peninsula

spirals through concrete to blow the Ladies
dunny door open and we imagine a swarm of dots

flying over our roof and gravel lined
with gone-to-seed parsley. An article I'm reading

says with global warming eastern Russia
will become an agricultural superpower (Iceland

and Canada too) and the beach I googled
is choked with seaweed so we buzz up and down

the coast looking for a patch of sea
and climate migrants (there will be many)

will be needed to work the empty thawed fields
and superpowers will crumble because they can't

grow food and Sarah Sentilles, quoting
a German biologist, says there's no single world

in which all beings are situated (the fly,
the bee, the bird and me watching them

are all in different worlds) and if a bee
looked down, might it see I'm worried

about lettuce and rain?

---

\* Couplets nine to eleven refer to Sarah Sentilles' *Draw Your Weapons* and biologist Jakob von Uexküll. The fourth couplet onwards refers to ProPublica, *The Big Thaw: How Russia could dominate a warming world*.

EILEEN KENNEDY

# The Wedding in September

Soon after I turned twenty-seven I did something radical—I married Kristen Baker. Kristen was a serious and creative woman. She had been a professional violinist but had taken a break after a wrist fracture that meant she lost feeling in her ring and pinky fingers. She now practised endlessly, working her fingers up and down the strings awkwardly for hours every day and, little by little, her playing had begun to improve again. Kristen's stoic commitment to the violin was one of the reasons I was drawn to her.

The wedding was scheduled for the end of September, at a beach park an hour out of Auckland—a terrible idea. Winter was over, but on the day there was a blast of cold wind blowing up from Antarctica. Our friends and family sat on plastic chairs on the green artificial lawn shivering in the chilly air.

Kristen couldn't stop shaking in her sleeveless white wedding dress. Her face looked blank and empty. She didn't usually wear dresses—or anything that wasn't dark. It was like looking at somebody else. I knew she couldn't feel the wedding ring as I slid it on her finger. For a split-second, the thought that her finger was numb and bloodless made me uneasy. When we kissed in front of two hundred pairs of eyes, her lips were smooth and cold. Everyone clapped.

I felt sick with stress the whole time. I didn't like large celebrations or any lavish attention, even on my birthday. After the ceremony I stood next to Kristen and drank glass after glass of fizzing champagne but it only made my stomach churn. Kristen was having a great time, giggling with the bridesmaids, her parents and some friends.

My bride was a person who usually stayed home and listened to classical music, but now she was acting like someone sociable and ordinary. She and her parents chatted excitedly about the new mall that had opened—they wouldn't need to order expensive watches online anymore. My mother hung back, out of place. Her being there added to my anxiety. I never knew what to say to her.

Just before dinner was served, I bumped into my ex-girlfriend, Jennifer. Jennifer was a good friend of Kristen's and mine, but it still felt odd talking to her right after marrying someone else.

Jennifer wore an off-white dress. An image of marrying her instead popped into my head.

'I'm so happy for you, Nick,' she said. I could hear the red wine in her voice.

'Thank you!' I said, with too much energy. 'How are things with you and …'

'Jeremy,' Jennifer reminded me. 'We broke up.'

'Ah.'

'But I'm not bothered.'

'Right.'

'I don't ever want to get married. Jesus, I couldn't imagine having to do, like, married-people things.'

'Married-people things?'

'You know—kids, mortgages, monogamy. No freedom.'

I contemplated this.

'But I'm really happy for you.' Jennifer rested a hand on my shoulder. It felt comfortable, and I relaxed for a second.

★

After people started to leave I was still wound up, even though all the hard work was over. The tension stretched into the following days and weeks. I had been a bit on edge ever since we had got engaged, but I had assumed that was just about the prospect of the big wedding.

Each night I lay in bed next to Kristen's sleeping body, awake for hours and hours. In our pitch-black room I had this terrible feeling she could have been someone else, another person stretched out in her spot, and I had no way of knowing unless the lights were turned on. I couldn't shake the thought. It finally hit me one night: maybe I didn't love my wife and she didn't love me either.

In the daytime Kristen practised violin in the living room. She had played for the Auckland Symphony Orchestra but since her wrist injury, she just taught students. Her doctor had told her not to play at all, but I knew Kristen wouldn't quit. She wouldn't know what to do without her true love.

About three or four teenagers with worried stares came to the house every day and Kristen taught them individually. She accepted only the most promising students—she made them audition first. Like her, they were brilliant but intense. Each one busily prepared pages and pages of music for recitals and competitions. Not one of the kids ever smiled or laughed.

At times it seemed that all Kristen did besides teaching violin and practising violin was attend to her injury. At first I had admired her dedication—and often I still did—but it had started to bother me. She did wrist exercises every morning and night, took an hour-long steaming bath each evening to relax her muscles, and visited a physiotherapist twice a week. I wished I could love something as much as Kristen loved the violin.

<div style="text-align:center;">⋆</div>

A few weeks after we were married, a stray cat followed Kristen home one day. It was skinny and grey, with darting eyes and a stub where its tail should have been. It gave me goosebumps.

'She's so cute!' Kristen stroked its scrawny back. 'I'm going to keep her.'

'What if it's diseased?'

'You worry too much.' Kristen went to pick up the cat but it hissed at her so she put it back down. 'It'll take time for her to feel comfortable with us.'

She poured some milk into a bowl. The cat lapped it up gingerly.

'You're not meant to give cats milk,' I said. 'It can upset their stomachs.'

The cat glared at me.

Kristen frowned. 'I used to give my cat milk all the time.'

'I didn't know you had a cat.' Apparently I knew hardly anything about my wife.

'What should we name her?'

'How about nothing? It's not ours.'

I knew we would end up keeping the little monster. That night it lay at our feet on the bed. Its glowing yellow eyes looked as if they were floating in the dark, drilling into me. When I finally fell asleep, I dreamed about those eyes. Every time I woke up—many times in the night—they were looking at me.

<div style="text-align:center;">⋆</div>

Soon after that it was Halloween, and Kristen and I were invited to a friend's party. We got ready and when it was time to go I found Kristen lying in our bed, dressed as a witch and reading a novel. She felt sick all of a sudden, she said, although her eyes looked bright and normal under the heavy black eyeliner.

'I'm going to stay here with my familiar,' she said, stroking the cat. 'You know, I almost think I can feel her in my pinky. She's so warm.'

Walking out into the night air by myself, I felt free and young again. And wasn't I still young?

Inside the party house there were about forty people dressed up for Halloween, talking in small groups while a Britney Spears song played. I immediately saw Jennifer, wearing a poufy white dress that was torn and streaked with dark red.

'Nick!' She hugged me. 'Good to see ya! No costume?'

I looked down at myself. I was wearing a Metallica T-shirt, black pants and Doc Martens. It could have been a costume but I smiled and shrugged. 'I forgot,' I said. 'What are you?'

'A dead bride.'

I joined Jennifer and a group of her friends. I nodded sometimes at things they said, and laughed when they did.

Jennifer leaned into me. 'We're gonna do some coke if you want some.'

I followed her and her friends through the string of vampires and sexy animals into a bathroom down the hall. Jennifer prepared a line for each of us on the back of a World Atlas, and we passed around a rolled-up Post-it note. I had done cocaine once before, at university, because everyone else was. Doing coke next to a toilet with my ex and her friends while my sick wife—probably faking, but still—was home in bed felt vaguely revolting.

We danced to pop music in the living room and now I couldn't stop talking.

Suddenly Jennifer said, 'Hey, let's go see the whole house!' She pulled my arm and skipped in front of me down the hall. She opened and closed each door we passed, until she came to a bedroom.

'This is lovely!' she yelled, and sat on the bed, mussing up the sheets.

I sat next to her. 'You were right about marriage,' I said. 'You know, you told me, about monogamy.'

Jennifer laughed. We were sitting so close that I could smell her beeswax Chapstick. I put my arm around her waist and she didn't move away. Without a second of thought, I leaned in and kissed her.

Jennifer scooted away like I had slapped her. 'Nick!'

I gaped at her. I didn't know what to say.

'You and Kristen seem *happy*!' Jennifer stood up. 'And you're some of my best friends! Jesus!' She shook her head. 'I'm going back to the party.'

I sat in the room for a second longer and then left the house out the back door, so I didn't have to tell anyone I was leaving. The night air wasn't liberating anymore; it was cold and unsettling.

Kristen was asleep, the cat stretched out languorously in my spot next to her. I tried to move it but it yowled and scratched my hand. Kristen rolled over but didn't wake up. The cat reached up to scratch me again. I backed away. I ran my bleeding finger under cold water, then I fell asleep on the couch.

★

The next morning Kristen played a deep, sad sonata on the violin. Her two numb fingers moved strangely, bending out at odd, stiff angles. The cat sat scowling at me for longer than usual, like it knew something. It wasn't just that I had kissed Jennifer, it was that I *wanted* to kiss Jennifer. Kristen and I hadn't had sex for a couple of weeks, but it wasn't just that. The violin vibrated through the house, melancholic and beautiful, and Kristen looked lost inside herself. I wondered if we would ever understand each other.

I listened to the music and pictured telling her what had happened, what I had done. Her face would change colour. She would go silent at first; then she would cry and call her mother, her friends, and Jennifer. Jennifer. I wondered whether Jennifer would tell Kristen what had happened if I didn't.

Kristen pulled her violin away from her chin and placed it delicately in its satin case. I opened my mouth. She loosened her bow and I cleared my throat.

'I have to tell you something.'

'Mmm?' Kristen wiped each string on the body of the instrument with a cloth.

'I kissed Jennifer last night, for a second. I didn't mean to.' I felt fake, like I was reading a script.

Kristen put her shoulder rest into the case.

'I was high.'

Kristen zipped up the case.

'It didn't mean anything.'

Kristen looked away. She picked up the cat and went into the bedroom.

For hours I didn't hear a sound. I almost wondered if she'd left but eventually she came out again. She was wearing a coat and carrying a small suitcase. I wondered how she had packed it so quietly.

'I knew I wasn't meant to get married,' she said. 'You should be with Jennifer. And I shouldn't be with anyone.'

'That's not true,' I said weakly.

'It is true, Nick. I've never really liked anyone in that way—not in my whole life. I just kind of thought getting married was … normal.'

I wondered why she was being so honest now.

'But you like Jennifer. So be with her instead.'

She rummaged around in the bathroom for a while, then picked up her violin case and clutched it tightly with her good hand.

'I'm going to stay at my parents,' she said.

<div style="text-align:center">*</div>

The cat walked in circles around the house meowing insufferably after she left. I tried to grab it but it darted behind the couch. In a burst of rage I hauled the couch aside and yanked the cat by its tail. It hissed at me and ran out the front door on its own. I slammed the door and sat on the floor.

I gulped in air, like I had been holding my breath for a long time.

JANET NEWMAN

# Kohekohe
*Dysoxylum spectabile*

Named by Pākehā
New Zealand mahogany

the polished wood
is red.

Flower panicles
and seedpods

grow from trunks
or branches

within easy reach
of introduced pests.

Once, the dunes were
covered with kohekohe.

Trees survive
on Kāpiti Island

which has been stripped
of possums.

From Moutere, the country's
largest sand dune,

I can see Kāpiti
where kohekohe forests

are an echo
of what they used to be,

the name itself an echo
like the sound

when I call it out
across the shelterless dunes.

Kohekohe, you almost
come back to me.

SUMMER GOODING

# Bendigo

Up the barley-coloured hill
we go to Bendigo.
My father tells me it's a ghost town
but I already know.
The air is thick with them—
chaotic whispers come
like echoing shouts into the void.
A ghost town it may be
but there are more than just the two of us
standing like stilled pendulums
in this field of rusted tussock
next to mineshafts that gape like waiting pits of mouths
under a sun that seems to scream
an urgent warning
with its heat—
get out get out get out!
My little feet itch with nerves
standing atop the hands of the dead
and those perpetually dying.

J.D. ROBERTSON

# See John Run

That summer we discovered John C was a vegan: a vegan who ate a lot of meat. This, apparently, was all right by him. He made zero effort to hide it. Barbecue after barbecue, sitting around in the sticky Auckland air, the old high-school crew back together just watching him go at it. If John C hadn't been the most memorable guy in school, boy, was he making up for lost time now.

John just plain flabbergasted us: the rapacity, the sheer volume of meat he managed to put away—glossy tubes of sausage, crisp bacon latticed high, sticky pork chops. Paper plates damp with grey flesh.

Beef brisket, he tells us, is his favourite.

*Beef brisket*? We're not quite sure what to say to this. We're not quite sure what to say about any of this, really.

John C laughs, reaching for more beef. 'You guys sure don't get veganism, huh?' We don't?

'No,' he dollops out a mass of brisket, 'you clearly don't.'

'Beef,' he says, 'is by far the best option from a vegan perspective. It's just simple maths—one dead cow, point-of-fact, yields so many more protein calories than, say, one lamb. Or a chicken.'

Except: doesn't he also eat lamb? And chicken?

'Lamb,' John nods, chewing, 'is another fantastic vegan option. Here, in this country,' he waves a hand, 'you'd be surprised—amazed, actually—if you saw what it's really like. All fresh green meadows, lambs frolicking, gambolling ... honestly, you should be jealous.'

In this lawn sauna? We doubt it. John's back yard abuts a poplar-lined creek, barely a trickle in summer but enough to thicken and sweat the limp air. The thought of all those woolly lambs frolicking about in the midday heat ...

'Thing is, they don't feel the heat. Not like we do.' John C points his fork at us. 'Point-of-fact: humidity, folks, is a human thing. Animals? Couldn't care less.'

The barbecue snaps and spits, while fantails flit and dive through the glossy poplar leaves, chasing down unseen insects.

'Anyway,' he sets his paper plate aside, 'I've come to a decision. I've made a resolution.'

A resolution?

'Yes. A big resolution.'

So what is this big resolution already?

'The marathon!' John grins at us. 'I'm gonna run the marathon.'

Oh, the *marathon*, we nod, staring at our shoelaces, smartphones. The marathon. The marathon? John C?

Oh, he is quite aware, John continues, that *some* people seem to think marathon running is this … what? … pretentious, middle-class urbanite thing? This very white, privileged, bougy affectation? But he begs to differ. Actually, point-of-fact, he's sceptical of the idea of white privilege in general. Was he so privileged? Because, thing is, he doesn't *feel* that privileged: diabetes out of control, knees utterly shot, all of which makes finding regular employment 'somewhat challenging'. Hence his struggle to find a decent job. Hence his being forced onto the benefit. Privileged? But what can you do—what can anyone do, really? He'd hoped the veganism would help with his weight, help his knees—

What about the impact?

'Impact? What impact?'

Of all that running—on his knees? Wouldn't a marathon, of all things, make it worse?

'No,' John says, 'it would not.'

He has, of course, heavily researched a technique, a special runner's technique, in anticipation of said knee issue. Don't we realise how much thought he has put into it? That he is not some fluffy-headed idealist?

Yes, no: we didn't mean any offence. We're just … concerned. And of course we can definitely understand his—

'Except you don't, do you?' John sighs, gets up. 'But it's like Celia says: it's gonna be my moment—no matter what. Even if nobody else gets it. Even if it's just Celia and me, at the end of the day.'

Celia?

'Yes, Celia.'

We've never met her but whoever this Celia is, she's gotta be one helluva girl.

★

Then just like that, we're decided. We'll all do it. The lot of us. We'll run the marathon too, we'll keep John company, keep him encouraged, supported. Because we do want to be good friends to him. We really do. But also, what we really want—if we're honest—is a front-row seat to the whole shebang. As of right now, how exactly this'll wash up is anyone's guess.

John, however, appears unenthused by this proposition. At last he agrees, though. He says he's happy for us to at least train alongside him. In fact, he says, now it occurs to him, might there perhaps be some mutual advantage—especially for us? We may find his progress motivates us. A little competition can be surprisingly effective.

*

Our first day of training we show up early. Between the motorway and mangroves, tide crawled out past the mudflats, we wait on the bike track, backs against the rusty chainlink fence to avoid the cyclists as they eddy past, lurid in their middle-aged lycra. It is hot. It is humid. It's only 9am. John told us he was coming; he told us he felt great, actually, first thing this morning. Said he had never felt as good as he did being vegan—he'd heard some vegan runners did a banana-only diet, every second day … that it was like being on *crack*. Imagine harnessing all that energy for your early-morning runs! he said.

*

By the time we catch up with him it's afternoon. Back at his place, dozing on his deck, John eases himself up at our approach.

We seemed to have missed him that morning?

John nods sagely. Yeah no, he didn't make it this morning. Thing is, he might be almost thirty but, he feels, that's not too old to train for a marathon. Far from it.

So—

So the problem—if anything—is Auckland itself. Auckland is plainly an armpit of a city, point-of-fact: a muggy, hilly armpit. How anyone can train, even short distances, in such oppressive, sticky air—steeply uphill at that!—really, is beyond him.

Okay …

He will do it, however! He will. If he is honest? He won't enjoy it as much as he might have otherwise. But what can you do?

Could we help him, then? In any way?

He rolls his eyes. Us? He's fine as is, to be honest. He has, he will admit, been cheating a little on his vegan diet. A tad. Hence? For the remainder of his training he will adhere more strictly. Simple. He has read from other vegan marathoners that broccoli and bananas are the key. If we really want to 'help', well! he laughs, we could always keep him supplied with bananas!

Bananas, we echo.

★

We run. Every morning that first week.

We run along the bike track, the mudflats and the mangroves, up through the park, running together, as seagulls wheel and tūī whistle and trill, drinking the pōhutukawa blossoms. We run and we run and run.

And we do not see John. Not once.

★

John is enjoying a creamy smoothie on his sun lounger.

So. When, did he say, he runs through the park?

'Um,' he makes a face at us, 'all the time.'

All what time, John? What hour of the morning, specifically?

John snorts. 'Please. That kind of thing? Running like that, under stringent routine, or whatever? I mean, are you trying to leach out all the natural joy? Or what?'

We just—

'I mean, to be honest, guys, I'm really not feeling this right now.'

Well, we're not really feeling it either, to be honest. We're not really feeling any of this, really. So we're thinking, actually, that we might just go and—

'My father thinks I can't run the thing.'

Sorry?

'My father thinks I can't run full stop.' He sighs. 'My father would be surprised to learn I can even walk up hills without needing urgent medical intervention. This all really goes back to that new house of his, by Cornwall Park.'

It does?

'Sure does. You see, when Dad moved in? He moved in midwinter. And suddenly everything was so cold—to him, I mean. This was too cold, that was too cold. The house was "freezing", according to Dad.'

Except, actually, the house was just fine. Insulation, heatpump: everything,

John says. But it got so it was just blazing in there. At least 30 degrees around the clock, point-of-fact. No one else could handle it. Couldn't stay in for more than a few minutes, couldn't visit full stop. Not when it was so blazing hot like that. His dad, of course, did not understand why he couldn't visit. What heat? He thought there was something wrong with John. That he was just making it up or something. And ever since … well, things have never been the same. He took it personal, and then he made sure it stayed personal, real personal. Every chance he gets—straight for the jugular. But yes, so anyway.

'Right. So, you want to know what it's all about? It's Dad. I just wanted to … I dunno, prove to him, somehow? That I'm not this thing he's made me out to be. You know?'

He pauses, stares into the middle distance, the poplars quietly shuffling in the wind.

We're not sure what to say to this.

'Funny thing is,' John says, 'I've actually never told anyone about this before? Any of it. You're the first ones I've completely opened up to.'

All right, okay, John. We … I mean, we had no idea. We'll show him, then. You'll show him.

★

'I actually prefer to run before dawn—civilian dawn, I should say. The hazy clouds, the moon for company … it's truly something. You're really missing out, you know.'

We'd wondered why he'd missed all our practice runs. Seems it's because he prefers to run in the dark.

The marathon is only a fortnight away.

'So?' he says.

So then, he's ready?

'I'm *more* than ready. I'm buzzed. This is going to make a huge difference for me, guys—Celia's right, it's totally gonna be my moment. Celia says she has been very impressed with my recent run times.'

This Celia again. We keep hearing about her, but we've never seen her. Guess we'll finally meet her on the day?

'Yeah, well. Thing is? I've decided I'm gonna run with her. Instead.'

With her?

'Yes—with her. I think it'll be much better this way, actually.'

We thought you were running with us; we thought that's what you wanted.

'So?'

So what happened? When did that change?

'When did what change? I never asked you to make any assumptions, now did I?'

Right. Okay.

'Oh, come on.' He snorts. 'You lot are *always* like this—everything's always about you. Isn't it. Nothing's really changed since school.'

We tell John he has a long memory, but for the wrong things.

He will not dignify that with a response, he replies.

<center>★</center>

We run the marathon. We're not entirely sure why, but we trained for it, and somehow it seems appropriate. We run as a group, the old high-school crew together, minus John C, and as a group we do okay, we think: nowhere near the fastest, but not the slowest either. Not once do we see John, though, not running with 'Celia' or otherwise. Not anywhere. And let's face it, we figure: he'd be hard to miss.

After the race is done, the runners long gone, the crew getting in to packdown, we find we're still standing there: waiting. For what? We ran the marathon. It's over.

When John answers his door, he doesn't open it all the way.

'Oh—the marathon,' he says. 'Yes. Isn't it so ridiculous?'

What?

'I mean, running a race that commemorates someone who ran *so* far, he point-of-fact literally died? Do you even know how many people die each year, running marathons?'

No, John, we don't.

'Well, it's a pretty big number, I can tell you that much. And I, for one, am not that crazy.'

We say nothing.

But he couldn't have made it anyway, he tells us. Got lead poisoning, of all things. From an old-school ice-cream scoop.

An ice-cream scoop. Weirdly, we can actually believe this. This we can just see: pink tongue over the pitted, worn black metal—so yes, you better believe he's seeking legal advice. Just think—how many other dodgy scoops must be

out there? Plus all those unsuspecting kids. Doesn't bear thinking about, now does it?

So, will he keep running?

'Running? Why? I have nothing to prove. I don't owe anyone an explanation.

Not even Celia?

'Who?'

Who indeed. And his father?

'Dad? What's he got to do with it?'

Everything, we thought you said. That that's what this was all about? You wanted to prove him wrong: your father in his too-hot house. He didn't believe you could run, and so this was going to be it? Your 'moment'? Your turning point, for your health, your life …

'Well sure,' John shrugs. 'Dad definitely likes his house warm! But what's that got to do with running? And as to his health, all he needs to do, really, is eat more bananas. So filling and nutritious: point-of-fact. That's what it comes down to.'

Bananas.

'Yup. Not enough bananas.'

We decide we could use a drink.

It's early, but we know a little place nearby that's open. The beer comes cold and quick.

We empty the first pitcher, and cast our minds back to school, trying to remember what John C had been like back when we were kids, back when we'd had Calc together.

Except had it actually been Calc we'd taken together? Which was the class we had with him again?

We get another round in. And find we can't quite recall. Was he actually in our year? Did he even go to our school? Now we really think about it, we're not certain we remember him there at all.

All we can say is, the guy sure is keen on bananas!

Although, then again, we never actually saw him eat one.

We've never even seen him with a banana.

WANDA BARKER

# Somebody Do Something

Somebody called a meeting
Everybody went
Something was said about a problem and someone
stood up, cleared their voice and sort of explained
something about the kids on the road and the grass was too long
and someone else said someone should do something
about it

Some voices got raised and some voices retaliated
Someone said it can't be that hard
Everybody said they were all too busy and some of them
argued about who was busiest
Someone said someone else should mind their own business
and another someone said someone really should do something
about the thing that someone thought was the problem
Everyone shrugged and chewed their nails
No one did anything
Meanwhile someone's kids were almost drowning
in long wet grass and other's nearly run over by the bus
Someone said it had to stop
Someone said good luck trying to get grass
to stop growing

So Ross picked up his lawnmower, gas in, put it in the boot
of the car and did the something which was to cut some grass
somewhere that no one close to the somewhere could be
bothered cutting so someone's kids didn't tangle in it or die
by falling under the bus
Someone said who cut the grass

Someone said did they get permission
Someone else said must've been someone we don't know
Someone else said it was Ross 'cos someone had seen him mowing it
he used a catcher and someone else said he doesn't even
live 'round here
Someone said someone should pay him something, anything
And someone else said he did it for free
Someone said why
Someone said some people are like that

ZOË HIGGINS

# The Round

In the back paddock is a round of bare earth
like the spot on a dog's elbow. Certain things

happen there: unseen music, the sudden sight
of blood on the ground then gone. Once,

a bawling steer was trapped there, ramming
its head against nothing then twisting back in panic

like it was wedged in a deer fence. Only air,
that we could see. Our neighbour Wayne,

who sets his lawn on fire once a month,
told me he stepped through it sideways

and saw shadows, heard his daughter's voice,
felt a great cold happiness that's never left him.

Liquored up some nights, he lets the old Cortina
drift sideways off the hill. It catches in the fence;

the Shadbolts pull him out come morning. Or else
he drives onto the beach and burns the engine

doing doughnuts till he sleeps. I found him
slumped across the wheel when the tide came in

one morning; tapped the window till he woke and fell.
*Just waiting for someone*, he said.

BRONTE HERON

# Bloom

The seal of blister foil bursts—
the sound is preserved
in the still kitchen.

The frozen residue of light
hovers in the mid-morning
like a muscle while I wait
for the Nurofen to be absorbed
and the coffee to swell in water.

I am standing at the threshold
of the day with what I know:

that the body holds on to doubt
like a grudge

and outside
the magnolia is the colour
of a bruise.

MARK EDGECOMBE

# Temaleti

Do you remember one lunchtime,
in the prefab that overlooked the rugby
field, staying after class (such a scholar)
with Zantana and Garland and Sita,
and asking me why God was always white
and always a man?       I was not
best fit to answer you (thirteen, Tongan,
a girl), I who'd come to Onehunga
by way of Belfast, Plymouth, Aberdeen.
                    I confess
that even now it's hard to banish
from my praying that unholy ghost,
created in my image, Palangi, greying.
Yet hear Paul's saying to the church at Kaletia:

    `Oku `ikai ai ha Siu pe ha Kalisi,
    `oku `ikai ai ha popula pe ha tau`ataina,
    `oku `ikai ai ke tangata mo fefine.

And for postscript—
nor teacher, nor student.

LILY HOLLOWAY

# and so I shape myself

boys used to say kissing my lips was like winning the lottery
so, for a while, I only drank pitchers of heavy cream
warmed it in my mouth by dragging mouthfuls
over that soft bed of tongue, sucking it through my teeth
tonight I vacuum all of the longlegs from bathroom corners
the air plucking spindles from bodies
and only for a moment do I give them backstories

the forty-something-year-old in my dms reminds me he's still there
by sending me the thumbs-up emoji over and over
and asking 'what u up 2 at the moment?'
I haven't blocked him yet for the same reason I don't kill
the creature on the kitchen floor who has lost some of its limbs
stomach up, wings buzzing on the linoleum

JAMES PASLEY

# John Campbell

'There are few things that I'm sure about,' Dad said, 'but one of them, one of them is that John Campbell is all washed up. Done for. He was always a hack but he's past it. Best thing he ever did was the surprise attack on Helen. Only good thing. Now look at him. No more jaw. No more heat. He's … He's …'

'He's had a good run,' I said, pulling the newspaper, which had John Campbell's broad clean grin on it, from his hands and tossing it on the seat beside me. I could see that this upset him. After a lifetime of him pulling things from my grip the sudden switch had pushed him way out of his comfort zone. Yet to actually reach over and grab it back would make him look childish. So he resisted, he ignored.

We were sitting in the chocolate factory café having lunch. We were surrounded by women. Women meeting friends, women looking after children, women scolding their elsewhere husbands. Like us, none of these people were from here. I knew this because locals hated the place; any mention of it and they pushed their finger into their nose and lifted. All of those women were Aucklanders, holidaying or retired. We were an outlier, an eyesore. There was only one other male: a young boy of about ten or eleven. He saw me looking at him and covered one eye and I wondered later if he knew it was going to happen.

I had been living with my dad and his dog for the past few months. I had had to come home with the pandemic raging. I had no choice. It was all reluctant. We were both in exile—from marriage, from the world. I had not told my friends or former colleagues that I was home. Truth was, I didn't want to be. I hoped to leave again, I thought about it every day, even though I knew that now that I was back I probably wouldn't. Yet if I told my friends I was there, if I confirmed it, I felt like that would solidify the arrangement.

We were living in his one-bedroom bach by the estuary. I was sleeping on an old cracked black leather couch. The couch was comfy and wide and the lounge was fine except there were no curtains so I woke early. I am normally a

late riser. Now Dad was the late riser.

All my life I had woken to find him finishing his two-egg omelette or already gone, but now he was retired he slept in, then spent his days slowly walking along the beach with the dog (it was illegal—the estuary was a bird sanctuary but he ignored the signs and never faced any consequences) or sitting quietly in this café that none of the locals liked, reading the newspaper.

He did not allow the same from me. Within a week of my landing he found me a job in town tutoring kids with ambitious parents, parents who didn't want their children dying no more educated than they were.

They were good people. Their children were not. Maybe they would be one day but right then something was wrong with them. I don't know where the line blurred or what happened but the parents and the children were like two different species. I noticed it as soon as I stepped into their homes. The parents were unselfconscious, warm, good. Not simple: they had their problems, their pasts and discontents, but they had come to terms with them. At least they seemed to have.

Their children, though, sitting on grey felt couches watching silently as I tried to impress the parents with my CV, were filled with something poisonous, something pus-like. I taught them, but I tried not to touch them. I knew it was ridiculous but I was afraid some of it, some of whatever that poison was, would rub off on me.

In the evenings I drove back over the bridge to the bach and we had sausages or steaks and salad (my dad hadn't touched a carbohydrate in twenty-two years) and watched HBO box sets. *The Sopranos*, *The Wire*, *Six Feet Under*. 'This isn't just television,' he said the moment Iris Elba was finally caught out, was finally put to sleep. 'It's art.' Thus he was telling me, without saying it, we were not wasting our time: we were educating ourselves. Despite this claim, he made sure to always be playing Scrabble or sudoku on his phone while watching. He played with women from middle America who thought New Zealand was a region in Mexico or Switzerland. They were not educated yet they held their own on the Scrabble board.

Some nights I got so frustrated with Tony Soprano I got into the car and drove back over the bridge into town. I drove slowly, looking out. I had always fantasised about coming from some small town, being one of any number of

strange off-kilter characters, but now that I was there I realised it was not for me. Once the sun set, there was nothing. Once the sun set, all you did was wait for it to rise again.

One of these nights it was raining lightly. The windscreen wipers moaned, dragging across the glass. I was driving around wondering what had happened to John Campbell, wondering when he had lost his edge. How did he end up on some breakfast TV show? It was fluff. He was so much better than that, I thought, and for a moment I contemplated emailing in. Asking him: John, what happened? Telling him: Pull yourself together, get back out there. There are secrets to uncover, politicians to hold to account. I got really hot and worked up all of a sudden thinking about all that talent gone to waste. I never got worked up. By all accounts that was my best trait.

The rain stopped but the windscreen wipers continued. I swerved around corners of quiet residential streets knowing something was off but unwilling to think about it. Instead I thought some more about John. I drove and drove until my hands got sore from my tight grip and finally I pulled over down by the estuary still on the town side. I was upset. My hands were shaking. I tried to keep my mind busy. I flicked the high beams on and off, on and off, watching the other side appear and disappear, watching the small dunes sitting like little mounds of flesh, untouched, unloved. There one moment, gone the next.

*

Another night there was some sort of doof party at the tavern across the estuary. I was sitting out alone on the deck with a glass of beer reading one of Dad's books. My phone vibrated. A message from Monica. Seems she knew I was home though I didn't know how.

'I'm at the tav,' she said. 'Come pick me up.'

I did not respond. I gripped the cold glass and did not respond.

*

On Monday afternoon I was tutoring one of the little boys. He was pleasant enough, though, like all of them, he had something lurking below the surface. He had to learn a poem off by heart so I taught him Rudyard Kipling's 'Our Fathers Lied', the shortest poem I knew.

'If any question why we died,' I said.

'Tell them ...' he said slowly, struggling to recall the final four words.
'Because ...' I said.
'Because ...' he said.
'Our fathers ...' I said.

He stared up at me, his clear eyes filled with someone else's hate, as if I was a monster, as if I enjoyed humiliating him.

'Lied,' I said. 'Because our fathers lied.'

<center>★</center>

On Thursday evening I was having a gin and tonic to celebrate the end of the working week. I only tutored four days, both because the parents wanted the kids to have Friday afternoons to themselves and because I presumed that one day I would have a normal Monday-to-Friday job again so I had decided I might as well make the most of this relaxed affair.

I was thinking about Monica.

For a while after my divorce we had slept together fairly often. We would meet at a bar, get blind drunk, cab back to my parents' house and try, and fail. How many times did I fail? Depressed or drunk, the rain came down and nothing ever went right. I remember one morning knowing my ex-wife was probably sitting in my armchair 200 metres up the road at our old flat as I lay beside Monica watching the rain come down. At that point I had given up eating and she ran her fingers softly over my hollow, over my ribs. She was all flesh and beauty, long hair, thick lips, and I could not provide for her. On those mornings I had never been more dead.

The morning after the last time, we discovered the back gate had been padlocked, as if my parents knew what we were doing, as if they had heard. We tried to get her over the back fence so she wouldn't have to face my parents but it was too high and the top was lined with sharp barbs. In the end I had to trudge up the steps and ask Dad to drop us at my car, then we went to drop her at her car, but it had been towed away so I drove her to the carpark for towed cars all the way out in Avondale and just left her there in the rain, not knowing if she could get her car out or not. She didn't care. She kissed me through the window, kissed me so hard she must have known. She always seemed to know things, seemed to know them long before I did. That was the last time I saw her.

<center>★</center>

Dad woke up one morning and could not see out of one eye. He must have hoped it would fix itself because he just sat there quietly and didn't mention it until I was heading out the door. Then he told me. Because I was late for tutoring I didn't pay him much attention. Told him not to worry. 'Probably just a bad day,' I said. I left him in his dark red robe gripping the bench and drove into town.

The next day it was worse. It was nearly violent how much it hurt to look at him. Something was wrong, something was seriously wrong. His eye had come undone. It had lost control and rolled entirely of its own accord. I thought of that little boy in the café covering his eye and began to cry. I went towards him and even though he could barely see he knew what I wanted and held up both hands to ward me off.

A few minutes later he asked me in the quietest, gentlest voice I had ever heard if I would drive him to the hospital. If that was all right.

The doctor confirmed he had had a stroke. The specialist said it had nothing to do with blood pressure but recommended more pills. They gave him an eye patch. He walked at a slight angle down the corridor to the bathroom and I asked the doctor, 'Will it get better?'

'I can't say for sure,' she said.

He was not allowed to drive. He could barely walk.

★

I messaged Monica a week later. The next day she was back in town.

We were still standing beside her car when she told me she had a boyfriend. A nice guy. He was living in Wellington but soon to make the move to Auckland. Then she asked when I was coming back and I didn't say a word.

'Let's go to the tav,' I said.

We took a table by the water and stared out. Across from us, the light glowed dimly from Dad's bach. She told me how different it was the last night she had come, the night she messaged me. She told me how everyone was chewing their lips and it was so dark out there you couldn't tell there was an estuary below; how a chain fence had been erected to stop idiots from falling in and drowning but someone managed to climb over it and give it their best shot anyway.

That night she came home with me and we were together, silently.

★

Six weeks passed. Dad's eye didn't improve. It didn't get worse but it didn't improve. A couple of times I caught him sitting on the grass, eye patch off, staring directly at the sun as if that would improve it. I asked him what it was like, how it was different, and got frustrated when he refused to answer. I don't know why but I felt like he should have understood things now that he saw everything differently, the focus all off and unclear.

One day he went to the specialist and she, not thinking, said, 'Damn, I thought it would have fixed itself up by now.' He was plunged into a depression, told himself it was never going to heal.

From then on, he stopped removing his eye patch. Thankfully he stopped staring at the sun, too. In a way we both grew used to it. Before, he used to ask every day when I was going to leave and get on with my life, but he stopped asking. We began to play backgammon like we did when I was young. We played most days. I never beat him. Not once, not once in my whole life.

One of the kids I'd been teaching topped his class. That afternoon I took him for a hot chocolate at the factory café. They served fancy hot chocolates: where the milk was whipped steaming hot and they slid two long chocolate bars into the glass and it was up to you to stir the slowly melting chocolate in. It was decadent and excessive and I saw on the boy's face a new love for me. He did not care about his grade but he would never forget that cup of chocolate. In going there, and in drinking that hot chocolate, he had been untethered. I had untethered him. It was what his parents wanted. They just didn't know that was how it had to happen.

'Do you like it?' I asked him.

'I'm not sure.'

'What's not to like?'

'It's good,' he said, seriously, 'but I feel weird.'

'Queasy?'

'Maybe.'

'You'll get used to it,' I said.

'Do you want another?'

'Yes,' he said, 'yes please.'

★

Monica stopped responding to my messages. I didn't blame her and soon stopped sending them. They had always been random gunshots fired into the bush. They weren't aiming at anything. At anyone. They were sent to know they could still be sent. They had no target. No meaning.

★

John Campbell was on the radio early one Friday afternoon. He was speaking when I left to take the dog for a walk along the road and he was speaking when I got back.

'I thought he was all washed up,' I said to Dad, since he looked to be listening closely.

'Maybe I was wrong,' Dad said. 'Still, the surprise attack was the best thing he ever did.'

I went to get the backgammon set and when I came back into the lounge he was slumped over on his side. I watched to make sure he was breathing. I wanted to put my phone under his nostrils to make sure, to see the little dots of condensation, but I was worried someone might text or call while the phone was there and wake him. It was silly but it stopped me. I watched from across the room instead. I clenched a backgammon piece in my fist, reminded myself the specialist said it had nothing to do with his blood pressure, and waited for his chest to move. But it didn't, not really, not for a long, long time, and for that period I could not be sure if John Campbell had killed him or just put him to sleep.

JOANNA CHO

# Daytime Activities

Wore the bikini today. Therapist would've asked why I tried to create intimacy, when the relationship is broken. I would've said, *I'm not! It's a hot day, my one-piece gives me a blocky tan*. Fergus says defensive people are the biggest liars.

He is at the stream, digging a canal to redirect it into the lake. He is standing shirtless, black shorts on, lurching down and then up with a large spade. He is good at manipulating environments, loves being in control—the purpose of manipulation being control itself. There is no functional purpose for him doing this; he looks hot doing this.

A shag spreads its wings to dry. I yank my bottoms up higher.

Shortly, Fergus waves me over. He has dug the channel right up to the edge of the flow, leaving a slim dam blocking the old from new. The water is rushing into the new canal, rapidly, but the dam is not strong enough and water bubbles through the base, ready to burst. We throw sand at the intersection, more and more, with urgency, until a higher, thicker dam is built and the old canal dries out. It dries out surprisingly quickly—a second glance and it was almost as if there had never been a stream there. Small grooves in the sand are all that remain.

We high-five.

That done, we find another activity. We connect the tyre to the surfboard with a rope and I hop into the tyre. Fergus lies on the board and paddles us out into the lake. The surface is still except for the ripples our bodies stir up—two coins in one big wish machine. I'm a poor swimmer, and Fergus has the biggest back muscles I've ever seen. He paddles to the drop-off, where the fish feed. I know he knows I'm watching, and his strokes become bigger and stronger.

Two hundred metres out, we take turns diving in. I've got goggles but all I can see underwater is a murkiness—everywhere there are clumps of spongy brown algae. I resurface and say *Giant peeling foot*. Throughout the trip I keep trying to think of interesting poetic descriptions that make him smile and

repeat what I said. I know it won't change anything, I know that when the three weeks are up I'll have to let him go, but I still want to reel him in a little bit more, tight. There is no functional purpose to this, either.

When he paddles us back we see a group of kids chucking sand at the shag who is in the shallows, feeding. The bird keeps ducking but doesn't move away. Fergus says there must be food there now, because of how we manipulated the current. I walk out of the water, bikini bottom bunching.

ERIK KENNEDY

# Official Printer to the Government

I was in the public square putting up a poster of a soon-to-be-executed traitor. It was hard to find space on the Wall of Proclamations, so I had to cover the poster of a recently executed traitor. Lucky him, his infamy papered over so quickly. A lark-like woman crossed the square towards me. 'Are you Ms Houllier who used to teach at School No. 76?' she asked. I admitted it. 'You taught my son fifteen years ago,' she said, and named him. The sort of kid who wore a scarf like a nappy. I asked how the lad was doing. Executed as a traitor, apparently. 'It's not because of anything I taught him,' I said defensively. 'I didn't say that it was,' she replied. We gave each other the three-fingered wave of the regime and went about our business. I thought about how being an official printer to the government was like being a teacher to the citizenry. I thought about how publishing the deeds of the condemned was like correcting papers. It was an appallingly hot day—too hot, really, for the crowd that would turn up at the two o'clock executions. Good thing, then, that my partner Anna would be in the square soon to open her kiosk selling floppy hats and sun cream.

MOLLY CRIGHTON

# Third of March

Light slants in like a clean American photograph,
1970s, sun bronzing the hospital-white side
      of an ice-cream van.

This afternoon I was pushing my bike home
next to the museum, under those golden elms,
and saw a man on the fallen leaves,
      spread-eagled
like an unseasonal snow angel.
My tyres crunched as I passed.

Swift in the blue breeze, I thought of him.
I wondered if he heard me, or if our lives crossed
like two people playing blind man's bluff
      on opposite sides of the planet,
where the seasons are reversed
and right now spring waits like a bomb.

One big bad thing has happened to me
every year for the past three years.
Nothing bad has happened this year,
though it is only March and every day
may be bringing it closer. But it has not happened
      yet.

The sun on my desk greys like a slow avalanche.
Summer is ebbing away like a distant headache.
      Soon I will cycle home again,

the world parting and reforming about me
like the wake of a distant ship.

NICHOLAS WRIGHT

# Karamatsu

Tree it stood something like a tree
slender, needle-leaved and glaucous to the eye
alone on the archery lawn at dusk—
seemed selfless in the council park.
In daylight a dynastic pine and absolute.
No kin to stand it stood to be beheld:
Stark anemone, cones' rolling tongues
purple-veined in autumn, shark-tooth seed.
A deciduous conifer, monoecious
in Chūbu, Kantō, now this Christchurch.
The celebrated end-of-season fire
will shiver to litter its bright syllables.
One could stand to eye the ancestral knot
the valued heartwood; but being nothing
more than I the tree stood civically instead
leaving something like a tree—that was all.

SARAH NATALIE WEBSTER

# Married, Widow, Divorced, Spinster, Nurse

A few years ago my youngest sibling, who lives in a different city, sent me on assignment to find the grave of our great-grandmother. They wanted a picture of the grave for the family tree they had been putting together, branch by branch, on Ancestry.com.

It was an odd feeling, finding out my great-grandmother's bones had been this close to me for years, buried in a cemetery just twenty minutes' walk from my house. Her 'remains', as we politely call that which is left behind by the dead. I imagined an old coffin enclosed darkly in earth, the bones, now cleared of their flesh, covered in scraps of still-decaying fabric. Bones which perhaps were once a similar shape and weight to my own.

Until my sibling started to look into it, my family knew almost nothing about my great-grandmother. There was no known grave, there were no photos, no letters, no heirlooms, no stories. My grandfather never talked about his mother.

She had died young, thirty-six, and he had promptly been put into foster care by his uninterested father. There was no trace of her until my sibling came across some newspaper articles from the 1920s:

> A-Punting She Would Go!—Magnetic Myra's Fairy Tales—Money for Nothing
> Driven From Home. Complaints By Husband, Allegations Against Wife
> A Drug Addict—Woman's Bad Life—Gaol for Six Months

The articles described how my great-grandmother, Myra Webster, swindled a few people with some creative fictions, the proceeds of which (the articles suggest) she spent at the races. According to the papers, her deceptions included disguising herself as a landowner to extract money from a woman wanting to build on the land, pretending to be a textiles merchant and taking orders for goods that were never going to arrive, and selling the deeds to a house she didn't own. The other thing the papers reported on, a scandal at the time, was the story of her divorce:

CAST INTO THE STREET: Husband Obtains Divorce Decree

Myra Webster threw her husband out into the cold street, sold their shop and all her husband's belongings, and ended up by disappearing.

ASHTON WEBSTER, thinking no doubt it was time he did something about it, asked the Judge of the Divorce Court to write "finis" to his married life.

He told his Honor, Mr. Justice Ostler, the story of his unhappy lot with his Amazon-like wife, commencing at the point where she acquired the habit of rushing away from him periodically to take a holiday.

It was after she and another woman took a shop in Dominion Road that the trouble reached a crisis, he told the court, for then his wife, assisted by her partner, turned him out of the house at 1.30 a.m.

After that his wife 'rushed away' on her last long holiday, taking his only child with her.

By what Webster said, however, she jumped into the proverbial fire, for her next appearance was before a Magistrate in the South Island, charged with false pretences.

She was placed on probation. She broke the rules of her probation then, and once again came before the court.

His Honor saw the force of Webster's argument, and in granting him a decree nisi also gave him interim custody of the child.

There's a definite tabloid tone to the article: Myra Webster 'threw her husband into the cold street', she was the 'Amazon-like' wife who had a habit of 'rushing away' from her husband to take 'holidays'. The journalist appears to relish her comeuppance—not only did she break the rules of probation, she broke the rules of being a good wife and mother and, in so doing, 'jumped into the proverbial fire'. I wonder whether the journalist would have used the word 'fire' if he (and no doubt it was a 'he') hadn't been speaking of a woman?

The only clues we have about Myra are from these half-dozen articles. The words of men:

> She thinks she can do what she likes. She tours all over the country … and thinks the police are so many logs of wood.

> I have had reports about this young woman. She has been taking drugs, drinking, and going to races and consorting with undesirable people. I know what I am going to do with her. She is either going to gaol or else to the inebriates' island.

> Myra Webster didn't rave and tear her hair when she stood in the dock … She remained silent while a three-cornered discussion took place about her. Only now and then she looked towards the senior detective or the magistrate and her lips moved or she made a little grimace.

Perhaps it is a sad story. A story of drug dependence, gambling, desperation and possible mental health issues. But I am tempted by other adjectives than the ones offered by the men whose job it was to prosecute her, rehabilitate her, or fill column space. I imagine my great-grandmother as a sort of Bonnie figure without need of a Clyde. I turn her into a symbol of feminist resistance or a beloved bandit. *Good*, I think when reading the articles. *Go girl*, I cheer her on. Like a bird that's escaped its cage to streak across the sky.

<center>*</center>

It's a Sunday afternoon in late June. One of those rare windless days where the absence of weather gives Wellington a sort of dreamlike quality, as if, without the wind constantly reminding you of your body or your body of the wind, you can start to doubt your own corporeal existence. The winter sun is thin and honeyed and I am wearing my green winter coat as I walk the hilly streets of Northland towards Karori cemetery.

The cemetery is huge, the second-largest in Aotearoa. It backs onto a reserve of native bush bordered by a dark rise of pine and macrocarpa. The office is closed so I navigate to Public 3 using a map on my phone: past the rose garden, the soldiers' section, the infants' section, the historic chapel, the Jewish cemetery, Roman Catholic 1, Church of England 2, Greek Orthodox.

When I reach Public 3 I'm expecting to find each grave numbered and each row lettered like seats in a movie theatre, but there are neither. For more than an hour I walk up and down the dilapidated rows looking for her name: Myra Pryke. It's not the name I'd become accustomed to or the name I had hoped to be looking for. She remarried a year before she died. My sibling found the announcement in the papers. I don't know what to make of this new husband, this new name. I hope she married for love but I am dubious, given the apparent state of her health. Was he an addict? Did she marry for money? Did she want someone to look after her? It's impossible to know.

I am trying to understand her. I have little knowledge of what it would have

been like to be a young mother in the 1920s. Did my great-grandmother feel as if her life was a steadily narrowing cul-de-sac? Were the swindles, the gambling, the mysterious 'holidays' all a bid for greater independence? She obviously didn't take well to the default role of housewife. Would she have liked, for instance, to have been living a bohemian life in Europe like Katherine Mansfield, eleven years her senior? Would she have liked to own her own business (she clearly was business savvy)? Did she like to dance (as I do)? Or sing (as my sibling does)? Was she part of the counter-culture of the era, swept up in swing dancing, speak-easies and jazz?

What I would most like to know is how she would tell the story. What words she would use if she were given the opportunity to describe herself. I have none of her words. The closest I can get is 118 words from her elder sister, May. They are from a letter twenty-seven-year-old May wrote to her husband in Wellington while she was taking an extended 'holiday' in Gisborne for the sake of her health.

> Dear Carl,
> Just a line to let you know I am keeping well. I don't think you ought to sell the furniture, because furniture is so dear at present. If I can possibly hang out till Xmas I will stay here, then that will give you a chance to get on a bit. Have you seen anything of Myra lately? Write soon and let me know how you are getting on. If I could have only felt strong enough I would have looked after the baby but you know Carl I felt that weak at times I could almost drop dead in the street. Well this is all the news at present so au revoir.
> Your unlucky wife

Five days later, on Monday 30 September 1918, the 'unlucky wife' went to her new job at the local tailor shop. Around noon she took her lunch break, walking, as she often did, through the town and down to Waikanae beach. Standing at the high-tide line May removed her gloves and then her hat, pinning it to the sand with a hat pin. Then she stood, turned to face the horizon, and walked into the water.

'I do not know why she signed off "your unlucky wife",' May's estranged husband told the coroner.

Two troubled sisters then. One of whom, at twenty-seven, wandered into the cold tide with her marriage certificate (only a year signed) tucked into her

dress, likely suffering postnatal depression. And the other, my great-grandmother, the wild one, who, at thirty-six, died on the surgery table from shock following an abdominal operation. Her liver was wracked, almost certainly from alcoholism (the death certificate cites an enlarged cirrhotic liver, a sign of alcohol damage or hepatitis).

I am trying to dig them up, these sisters from a hundred years ago. I am trying to piece them together. So much is missing—it's mostly gaps and white space. I can't find anything of Myra outside the tabloids and police records, but I have two more artefacts that bring me a little closer to May. One is a letter addressed to May's son Robert, from her friend May Dreaver. Robert was less than a year old when his mother drowned. At the time of her death he was in the temporary care of a nursemaid in Wellington. The letter is dated 21 April 1939. In it May Dreaver tells Robert that his mother was 'my dearest chum' and that they, 'the two Mays', were 'inseparable for ten years', playing hockey, taking long walks and competing in running races. May describes her friend as 'a beautiful girl with wonderful grey eyes and glorious curly hair', 'a natural poet' who loved big hats and was fond of gathering wildflowers. She goes on to say:

> She, your mother, was of a very spiritual nature and anything gross or carnal shocked her soul. I was always a good swimmer but although your dear mother was quite fearless in the water she never learnt to swim, yet she would go in with us right out of her depth and just laugh when we had to help her back to shallow water. She was of a very dreamy nature and lived often in the LAND OF DREAMS.

> I firmly believe she had so much of the ANGEL in her nature that Heaven was really the best place for her. Things used to hurt her that only made me smile. Be always thankful laddie that you had a mother any boy would be proud of; she never could do anything wrong because her soul was so pure. It is a great heritage A GOOD MOTHER and perhaps someday you will have a little girl MAY like her.

The letter ends with May telling Robert that next time she's in Wellington they should meet, and if he sees her name in the paper, to get in touch.

More words. More clues. Five hundred of them in this letter, sixteen of them oddly capitalised like a code or an erasure poem:

    TWO MAYS
    HOCKEY

                     RUNNER      RACE

                     LAND OF DREAMS

ANGEL

                        A GOOD MOTHER
        MAY                            TUI

    OTHER MAY

The idiosyncratic capitalisation feels indicative of something we do when we read—giving greater emphasis to particular words and phrases, crafting our own story, like drawing a constellation from a scattering of stars. I wonder if this is what drives my sibling to stay up late piecing together our family tree? Are they searching for their own reflection? Some explanation for who they are, how they came to be here, what they should do about it all?

HOCKEY, RUNNER, RACE. These words, curiously emphasised by the 'OTHER MAY', feel the way a really good horoscope feels for a non-believer. For a moment you could be seduced into a sense of cosmic design. I come from a family of runners and hockey players. It feels strange to come across evidence of this athletic ability pre-scripted in my family so long ago. What else is inherited? In what other ways do our ancestors continue to show up in us, the past continuing to echo through the present?

In addition to this letter, found in May's son's papers, was May's photograph. A posed, seated portrait in black and white. May is very striking, with long, dark, curly hair and grey eyes. She is looking off into the distance and appears melancholic and lost in thought. She wears a black dress trimmed with white lace, and in her hands she clutches a black leather-bound book.

THE LAND OF DREAMS
What is the book?
Who took this photograph?
Who made her dress?
Did my great-grandmother look like this?

An image keeps returning to me of a horse in a pasture. I think of the perimeter of a fence—how the circumference of possibility in my life is so much wider than it was for Myra and May. My great-grandmother, the wild one, seemed enraged by the circumference drawn around her, bucking against its hard limits, while her elder sister pinned her hat to the sand and waded into the land of dreams.

★

There are too many graves. Public 3 is too scattered and it's getting very warm in the sun. I haven't been searching systematically. The sense of kismet with which I began the search (good weather, good hair day, detective-like coat) was giving way to a familiar kind of suburban disappointment. But then I have an idea. If the council website can give me Myra's plot number, it can presumably give me the plot numbers of other people too, and I can use these plot numbers like coordinates to find her.

Yes! This is it!

I start visiting other people's graves. Bessie Julia Haynes, Flora Jane Gray, Mary Mason, Harriet Dell, Fanny Jane Little. I choose graves with names I can read, which haven't been written over with moss or lichen or patinaed to the point of illegibility. I choose graves I can sit on, especially the long, low boxes of cement, or occasionally marble. It takes a while to enter each name into the search page, then I wait, watching the circle spin. Each time the plot number is a little closer to hers, 200C, it feels like a small prize.

I start near the road and find the As:

Janet Moss, 76A
Grace Emily Moore, 99A

I go back the other way and find George Ireland, 99C. Battleship. I'm getting closer. But the numbers jump around, they don't make sense. I walk

ten graves to the right of William Mouldy, 190C, and find Charles McKay, 229C. I don't understand why I can't find her. I've been searching the same three rows over and over. I am awed at how elusive she is, even in death.

In my mind I can see the letters clearly: large seriffed capitals handsomely etched into marble, MYRA PRYKE, 1897–1933. I look forward to the inscriptions, some kind words to counterbalance the newspaper articles. Something simple, traditional, boring even—'beloved wife', 'beloved sister', 'dearest'. Finally, near to the point of giving up, I find:

Edith Alice Christie, 199C.

Her neighbour. 200C must be the grave to the right.

The grave is unmarked. There's no headstone. No concrete tomb. No marble. It's a shocking absence among the other elaborate 1930s plots. No letters, no dates, no dedications. Just a single dead tree and a carpet of leaf litter from the overhanging gum.

I surprise myself with how devastated I am. I'm crushed by the absence of her name and those two dates separated by a thin horizontal line, representing the life that precariously spanned 1897–1933. I'm surprised at how I long for those letters and numbers.

I never thought I could be so sentimental about a stranger's grave. I sit down on her neighbour's tomb and speak to Myra (another thing I never pictured myself doing). I tell her I'm sorry her life ended the way it did. I tell her about my own life, the book I'm writing, my troubles with men, how upset I am by her nameless grave. Why was her life considered one that could be forgotten?

★

Later at home something starts to bother me about the listings on the council's website. I start looking through my search history to figure out what it is. Each person's listing includes the usual things: name, age, burial date, funeral director, cemetery, section, plot number. But there is also a field labelled 'occupation', just below name and age.

The men's occupations are varied: labourer, bricklayer, civil servant, farmer, tally clerk, carpenter, grocer, manufacturer, auctioneer, MP, minister, fine art dealer, student, mariner, journalist, bootmaker, confectioner, furnisher, cook, salesman, plumber, station master. But for the women of Public 3 who died in

the 1930s there are only five 'occupations': married, widow, divorced, spinster, nurse.

<center>*</center>

I'm writing this halfway through 2020. I'm thirty-four years old. My only dependants are my houseplants. Of my three sisters, only one of us, my sister Petrea, is married. Petrea is an ex-professional hockey player and dedicated high-school teacher. Her first child was born at a time when the prime minister of her country is a thirty-nine-year-old mother of a toddler.

Petrea's twin sister Melanie spent most of her twenties working in marine conservation on islands in the Indian Ocean and the Pacific. She's a surfer, diver and constant traveller who has recently been talking about circumnavigating the globe solo in a yacht.

My youngest sister, the one who has been researching our family tree, I no longer refer to as my sister. She is my sibling. And I no longer refer to her as 'she'. George is non-binary. For George, it was a relief to finally discard the labels 'woman' 'she' 'her' and 'girl', none of which ever felt comfortable. The only time George uses a gender-specific pronoun now is when they're performing their drag-king persona. It is only then, on stage in a fireman's get-up or a three-piece suit, that George goes by 'he'.

Three generations separate my siblings and me from our great-grandmother and her sister. A hundred years ago it was 1920. Myra is twenty-three, her elder sister May has been dead two years. Myra is a wife and mother to an eighteen-month-old son. In nine years' time the couple will cause a public scandal when they apply for a divorce. Four years later she will be dead.

<center>*</center>

On an autumn morning I get a phone call from the memorial company to tell me the gravestone for Myra is ready. I drive to Karori. There's no wind. The sun is slanted and soft like the day I first visited the graveyard five years ago. In my little hybrid I navigate the narrow roads to the cemetery's northern side.

This time I don't have to hunt for Myra for hours. I look for the big gum at the back of Public 3, the one with the low, heavy branch that extends over the graves like a protective arm. I park my car and clamber up a steep rise into the rows and find her right away. On her formerly empty plot now sits a handsome slab of black marble, and there, etched into the smooth face of the

stone, my great-grandmother's name in bold seriffed letters. Her name underscored by two dates, bridged with a dash.

Something else is different about her plot. The tree, which I'd been certain was dead those years before, is alive. It's bigger. It looks sturdy and strong. In defiance of autumn, the tree is festooned with small leaves. I wonder whether the roots have found their way into the coffin below or are wrapping around the shape of it. I wonder whether my great-grandmother's remains once provided sustenance to this tree. In any case, the tree is healthy and growing, the new young leaves reaching to take what they can of the day's late-autumn sun.

MAJELLA CULLINANE

# Caselberg Trust International Poetry Prize 2021 Judge's Report

Irrespective of a judge's particular tastes, there are elements that make a poem rise to the top: the careful craft of language, rhythm, clarity and originality, especially in terms of imagery and voice. The subject matter of entries was broad: political and social commentary on recent events in Aotearoa, nature, love, ghosts, death and identity. Many poems had striking lines but were let down because the tone or rhythm was sporadic, or the observation clichéd. Others suffered from poor line endings or opaque language that rendered them difficult to connect with. Many would have benefited from closer editing and precision—often 'less is more'. The use or lack of punctuation is a controversial topic in contemporary poetry. While poems can work without it, a blanket lack of punctuation that ultimately impedes or jars the reader is best avoided.

**Winner**
**Sophia Wilson**'s poem 'Sea-skins' drew me back again and again with its inventive language and the assuredness of its voice. The leaps of imagination between stanzas, between the ordinary and extraordinary are surprising and original. 'Sea-skins' appears on pages 171–72.

**Runner-up**
'Kintsukuroi' by **Jenna Heller** (see page 173) is a list poem on the nature of grief that combines startling nature imagery and emotional insight:

> And what of the swifts that dazzle in aerobatic flight? That pierce the
> twilight with elfin screams and finally rest in lofts and spires?

**Highly commended**
'At Bluecliffs' by **Alan Roddick** is a carefully drawn narrative poem that charts a day of fishing:

> a Fiordland lake where big trout lined the shore / like wallflowers at a dance

'Inversion Layers, Hāwea' by **Jilly O'Brien** is meticulously crafted with some lovely examples of personification:

> May is a swindler. May sells promises of yellow flowers / upturned towards the light

'Kōanga Ngākau' by **Derek Schulz** is ambitious with a bustling energy and striking imagery:

> the caress of a kaitiaki checking out my inner ear / and (…) Frost began to spread across her blood-white flowers …

'Ode to L' by **Sandie Forsyth**, with its confident, engaging voice, is a poignant lyric on a woman's sexual identity:

> I was already a foot taller / and had a longer stride / and lesbian was me and mine

'The Domestic Assistant' by **Jane Simpson** struck me for its assertive, unapologetic pronouncement of identity:

> she is a staccato fiddle in the legato violins, // sweeps and dusts in tantalising silences, leaves her mauri in every room …

SOPHIA WILSON

# Sea-skins

> ... and the angry waters dashed themselves against their narrow bound ...
> —Phoebe Cary, 'A Leak in the Dike'

In the ruins of this floating house, there's comfort in simple turns:
the click, click, click of spinning wheel,
small wooden beads; the next round of medicinal pills

I have a dermatological condition that involves
shedding malignant layers

A physician displayed my skins on a bulletin board,
stuck pins in the scabs, voodoo style
He banished me to a moonless sea, told me I was a sinking boat,
made so many holes in me, I was anyone's for the taking

Pirate-nurses tied my tongue to a stone,
and flung it overboard

Who can blame them?
All I want is to get to the X, get drunk, or get into a hammock
with strange seamen, because that helps me forget
what's unfurling in the future

Some mornings cold waters engulf the sun,
waves pound the portholes, and all the life-rafts go limp

Mostly I'm trapped with my babies
in a darkened hull,
floodwaters rising exactly as predicted

Injustice is a hard rash to soothe: each circumnavigated wound
is like the Dutch boy's small finger plugging that dike

My spine is a displaced mast, my navigation ataxic:
Consumptive cells conjure up
yet another metastatic colony,

but on the keyboard-rosary, click, click, click,
a new poem surfaces: sleek-skinned, seaworthy,

set to survive invasive latitudes and longitudes—
a savvy sigh, a seabird's song,
a swift and salient filling of the sails

JENNA HELLER

# Kintsukuroi

1. That there are five stages of grief does not mean you will experience them in order or even at all.

2. The common swift stays airborne for up to ten months every year, pausing only for severe weather. And though it has been nine years since your mother died and twenty-nine since you last saw your father alive, you have hunkered down in the quiet as grief flies the nights, the weeks, the years. Weaves your days like a golden repair.

3. The gumption. To braid together threads of memory with future plans and present worries into a carefully constructed nest.

4. And what of the swifts that dazzle in aerobatic flight? That pierce the twilight with elfin screams and finally rest in lofts and spires?

5. There is no time to lollygag. The bargaining continues. And acceptance? Well, that requires some other kind of act.

# Landfall Review Online

www.landfallreview.com

Reviews posted since April 2021
(reviewer's name in brackets)

**April 2021**
*Bus Stops on the Moon* by Martin Edmond (David Eggleton)
*The Strength of Eggshells* by Kirsty Powell (Catherine Robertson)
*Sprigs* by Brannavan Gnanalingam (Catherine Robertson)
*Monsters in the Garden*, eds Elizabeth Knox and David Larsen (Tim Jones)
*Letters of Denis Glover*, ed. Sarah Shieff (Robert McLean)
*Refocusing Ethnographic Museums Through Oceanic Lenses* by Philipp Schorch et al (Emma Gattey)

**May 2021**
*Bug Week* by Airini Beautrais (Rachel O'Connor)
*Map for the Heart* by Jillian Sullivan (Tim Saunders)
*National Anthem* by Mohamed Hassan (Erik Kennedy)
*Childwood* by Denis Welch (Erik Kennedy)
*The Sets* by Victor Billot (Erik Kennedy)
*Common Ground* by Matt Morris (James Beattie)
*Searching for Charlie* by Tom Scott (Helen Watson White)

**June 2021**
*The Mirror Book* by Charlotte Grimshaw (Philip Temple)
*This Is Not a Pipe* by Tara Black (Robyn Maree Pickens)
*Timelights* by Martin Edmond (Robyn Maree Pickens)
*More Miracle than Bird* by Alice Miller (Vincent O'Sullivan)
*Ephemera* by Tina Shaw (Emma Gattey)
*The Savage Coloniser Book* by Tusiata Avia (Siobhan Harvey)
*Magnolia 木蘭* by Nina Mingya Powles (Siobhan Harvey)

**July 2021**
*Ghosts* by Siobhan Harvey (Jordan Hamel)
*Five O'clock Shadows* by Richard Langston (Jordan Hamel)
*Fancy Dancing* by Bernadette Hall (Jordan Hamel)
*Ngā Kete Mātauranga*, eds Jacinta Ruru & Linda Waimarie Nikora (Emma Espiner)
*The Swimmers* by Chloe Lane (Wendy Parkins)
*Victory Park* by Rachel Kerr (Wendy Parkins)
*From Suffrage to a Seat in the House* by Jenny Coleman (Giovanni Tiso)
*Crossing the Lines* by Brent Coutts (Giovanni Tiso)
*Loss Adjustment* by Linda Collins (Sally Blundell)

**August 2021**
*A Clear Dawn*, eds Paula Morris and Alison Wong (Renee Liang)
*The Disinvent Movement* by Susanna Gendall (Rachel O'Connor)
*Greta and Valdin* by Rebecca K. Reilly (Rachel O'Connor)
*Somewhere a Cleaner*, eds Adrienne Jansen et al (Chris Tse)
*Second Person* by Rata Gordon (Chris Tse)
*ngā whakamatuatanga / interludes* by Vaughan Rapatahana (Chris Tse)
*Pins* by Natalie Morrison (Claire Lacey)
*Things OK with You?* by Vincent O'Sullivan (Claire Lacey)
*I Am in Bed With You* by Emma Barnes (Claire Lacey)
*The Wilder Years* by David Eggleton (John Geraets)

**September 2021**
*Scorchers*, eds Paul Mountfort and Rosslyn Prosser (Emma Gattey)
*In Bed with the Feminists* by Liz Breslin (Jordan Hamel)
*Felt* by Johanna Emeney (Jordan Hamel)
*To the Occupant* by Emma Neale (Jordan Hamel)
*Bluffworld* by Patrick Evans (Vaughan Rapatahana)
*More Favourable Waters*, eds Marco Sonzogni and Timothy Smith (Angela Trolove)
*This Twilight Menagerie*, eds Jamie Trower and Sam Clements (Angela Trolove)
*Colouring My Soul* by Kat Maxwell (Jessica Thompson Carr)
*Gaps in the Light* by Iona Winter (Jessica Thompson Carr)

# The Landfall Review

# Writing Decolonisation, Rewriting Sovereignty

Emma Gattey

**Two Hundred and Fifty Ways to Start an Essay about Captain Cook** by Alice Te Punga Somerville (Bridget Williams Books, 2020), 120pp, $14.99; **Imagining Decolonisation** by Bianca Elkington, Moana Jackson, Rebecca Kiddle, Ocean Ripeka Mercier, Mike Ross, Jennie Smeaton and Amanda Thomas (Bridget Williams Books, 2020), 184pp, $14.99

Until relatively recently, Alice Te Punga Somerville (Te Āti Awa, Taranaki) seemed like one of literary and academic Aotearoa's best-kept secrets. Whether parsing the poetry of Robert Sullivan, tracing the genealogical and creative connections between Māori and Pacific peoples, reformulating methodologies for Indigenous biography, history and literary scholarship, or dissecting the alienation of not-quite-belonging in either the English Department or Māori Studies, she is some kind of genius. And then she was awarded a Marsden Fund grant, published *Two Hundred and Fifty Ways to Start an Essay about Captain Cook*, contributed a heartrending chapter to *Ngā Kete Mātauranga: Māori scholars at the research interface* (Otago University Press, 2021) and delivered the 2021 Michael King Memorial Lecture. Irrepressible. With the publication of this accessible BWB Text alongside her other projects, Te Punga Somerville will be recognised as an invaluable public intellectual for so-called 'post-colonial' Aotearoa.

Scholarship on Captain Cook abounds. Literally, it fills entire wings of libraries. This is a different kind of ink-spilling: historical, literary, interdisciplinary, polemical. As distinct from the infamous anthropological battle over Kānaka Maoli (Native Hawaiian) interpretations of Cook and his subsequent death in Hawai`i, Te Punga Somerville ventures on a different tack. Not merely de-deifying Cook, *Two Hundred and Fifty Ways* takes an academic hatchet to (neo-)colonial interpretations, norms and myths. This is fresh, emotive and supremely compelling Indigenous-centred revisionist history. Prioritising 'stories of Pacific connection and anti-colonial Indigenous-centred narratives', Te Punga Somerville is dedicated to shifting the focus of Oceania's history away from its colonisers 'and back to the relational, relation-filled context of the broader Pacific region'. With the acuity and Indigenous feminist scholarship of Haunani-Kay Trask, Leonie Pihama and Linda Tuhiwai Smith, and its author's own dark humour, this slim volume offers 250 wry, erudite lessons in changing history, and changing our reality.

Essentially, Te Punga Somerville challenges the fallacy of a single narrative, or a single starting point for histories. Revelling in multiplicity, cultural mythologies and intellectual honesty, she grapples with orientations

and origin stories—where and when to begin 'the history of this place'. Starting points, she argues, have 'revolutionary significance' in that they foreclose the telling of histories, predetermining *what* is remembered, and *how*. Revealing the profound messiness of imperial histories, and the complexity and agency of Pacific peoples, Te Punga Somerville debunks dominant stories and hero narratives. As many have before her, she makes the case for undoing Cook's apotheosis. But this is part of a larger project of re-forging and re-theorising history. Along with allied disciplines, history is called to account for its complicity in imperialism. Thus, the importance of decolonial history could not be greater: 'One of the projects of Indigenous people is to push back against colonial narratives.' This kaupapa is essential because it liberates imagination, allows us to see 'alternative future[s]' and is world-making. Te Punga Somerville argues we must expose the gendered, classed and racialised reproduction of settler colonial history, which 'naturalises, produces and memorialises' both the logic of settler presence and of Indigenous absence. In turn, this requires us to ask 'What's an archive? What's history?' How do you use Indigenous historical texts *as* historical texts? Whose voices matter? For each question, Te Punga Somerville reminds us, 'The possibilities are endless and the stakes are high.'

Ranging from the punchy one-liner ('The cursor is blinking. All this fatal impact is giving me writer's block') to the mini-essay, these 250 paragraphs give the feel of intellectual bricolage at its politicised best. Her metaphors are crisp, acute diagnoses of neo-colonial society. From internet gun-listings to musings on academic methodologies, this work is interdisciplinary, wide-ranging, singularly focused, taut, baggy: an explosive paradoxical mix. In this work, Te Punga Somerville seamlessly blends literary studies, art history, intersectional feminism, history, anthropology, cartography, Indigenous and Māori studies and dark humour. Like many Indigenous scholars, she underscores the nexus between imperialism and climate change. She re-endows Indigenous women with sexual and political agency, with *selves* and subjecthood. She reminds us to question the content and context of what we read, hear and learn.

Humour, here, is Indigenous power. It is part of reclaiming histories and 'turn[ing] them inside out … mak[ing] them our own … We laugh, and together we both affirm and reject Cook's Pacific.' Humour is also, of course, a coping mechanism, 'because if you didn't laugh you'd cry' over these histories, over the mendacity in collective memory and national commemoration. This anti-colonial badinage does not disappoint. The 'mansplaining' of Indigenous studies, for example, is 'to Columbus': 'to discover something that had already been known by others for a long time'. Some gags, however, are ambiguous and

awkward: we want to laugh at the racist Pākehā but feel uncomfortable about that laughter, because it simply is not enough. Another reason the humour is dark, though, is the underlying sense of futility, of internal colonisation, which Ngũgĩ wa Thiong`o says demands 'decolonising the mind'. And death is always dark. This kaupapa has devastatingly real health and mortality implications for Indigenous scholars, especially women, signalling that anti-colonial 'academic labour contains its own kind of slow-motion punishment. This work is killing us.' Still, the kaupapa is not masochism but mission, vocation, utu. In all its manifestations, for *everybody*—without exception—colonialism is exhausting.

In her indictment of Aotearoa's fraught pedagogical arena, Te Punga Somerville pre-empts certain predictable responses to 250 *Ways*, future-proofing her own scholarship against racism. In the voice of a hypothetical (all-too-real) stranger, she barks: 'This isn't history. This isn't academic. Where are the footnotes? ... That's what happens when you ask Maories [sic] to write about Captain Cook. They break the rules. Maybe they don't even know the rules.'

Te Punga Somerville self-identifies as an irredentist, which should alarm precisely nobody. Like 250 *Ways*, *Imagining Decolonisation* reminds us that colonisation is 'a structure, not an event', an enduring invasion that means genocide, expropriation, cultural alienation and the rest.[1] And thus, decolonisation is not a metaphor, or a tick-box in cultural awareness training. It means land-back. It means cultural, intellectual, political and economic sovereignty. As Bianca Elkington (Ngāti Toa Rangatira) and Jennie Smeaton (Ngāti Toa Rangatira) clarify in their introduction, *Imagining Decolonisation* emerged from a project on decolonising urban spaces. Through personal kōrero, as well as empirical and historical analysis, this multi-authored text reveals how colonisation has impacted on Māori and Pākehā, and how these impacts endure. It further reveals the acts of decolonisation needed to re-indigenise and restore ecologies, to heal human and non-human relationships, to eliminate socio-economic disparities and racism, and to build a more just society. While decolonising efforts must be led by Māori, Pākehā solidarity—in public and private—is essential to the kaupapa, because 'decolonisation is the work of all of us'. This pukapuka sets out to 'demystify decolonisation', to reveal how and why this is something every New Zealander 'can get on board with and benefit from'. But it achieves so much more than this modest mission statement. A wānanga in print, this book is a meeting of hinengaro (intellect) and ngākau (heart), of Māori and Pākehā.

With a clear, cumulative structure, the co-authors build the reader's comprehension of what colonisation is, and 'consistent and continuous' Māori resistance movements (Mike Ross); different global forms of decolonisation

and the specific kaupapa Māori-inspired version most apt for Aotearoa (Ocean Ripeka Mercier); the impact of colonisation on Pākehā and other non-Māori New Zealanders, and 'practical ideas' for how Pākehā can start doing the mahi of decolonisation (Rebecca Kiddle; Amanda Thomas); and the success stories of mātauranga Māori: the stories of tangata whenua that 'remain strong despite the efforts of colonisation to suppress and co-opt them' (Moana Jackson). Although the version of decolonisation endorsed here does not demand the 'removal of the coloniser' feared by some Pākehā, Mercier (Ngāti Porou) emphasises the need for systemic overhaul, 'a fundamental shift in the ideas, knowledges and value sets that underpin the systems which shape our country'. Decolonisation means liberating minds and transforming the world.

The intertextual resonances are most striking between Te Punga Somerville and Jackson (Ngāti Kahungunu, Rongomaiwahine, Ngāti Porou), who focus on how Māori have always resisted the 'stubborn past tense' of colonisation. Refusing either to relegate history to the past or to accept Pākehā histories, Māori have committed to honouring and revitalising their own kōrero. Jackson describes the ideological metamorphosis of history into 'a kind of rebranding', which depicted colonisation as 'a grand if sometimes flawed adventure that was somehow "better" here than anywhere else'. Always a show-stealer, Jackson discusses how the capitalism, sexism and racism of colonisation disrupted the tikanga of Māori relationships with the land; corrupted the roles of wāhine and tāne; and reduced Māori to stereotypes (the 'warrior race' or 'noble savage') and their 'sacred and complex understandings of the world into simple myths and legends'. Beyond these 'intruder stories', he also canvasses alternative constitutional models, and the radical, transformative potential of history, or how 'the identification and "un-telling" of colonisation's past and present lies' can help to build new relationships and futures.

Elsewhere, Te Punga Somerville has written of Tuhiwai Smith's *Decolonizing Methodologies*: 'Linda's book warmed Indigenous connections before, and after, they had been made.' Both texts reviewed here are similar conduits: serving as bridges between Māori and other Indigenous scholars, heat conductors, manifestos, pou (pillars). This is writing as a form of, and route to, sovereignty. Despite the clear focus on Aotearoa, transnational Indigenous solidarities are writ large in both books, with the results of colonialism and imperialism traced through many lands. However, these writers do not limit themselves to intra- or inter-Indigenous connections. Instead, they sear solidarity into much broader swathes of humanity, trying to incline all audiences towards supporting decolonisation and Indigenous sovereignty. This kaupapa, each author shows, should be *all* our kaupapa.

At a time when the national history curriculum is being solidified; when *He Puapua*—the expert report intended to ensure Aotearoa's compliance with the United Nations Declaration on the Rights of Indigenous Peoples—has been labelled 'separatist' and 'an action plan to destroy democracy'; and when mātauranga Māori is abused and wilfully misunderstood, these short texts are indispensable antidotes to historical ignorance, inertia, quietism, populist racism and aggression. Continuing its legacy of educating New Zealanders through 'short books on big subjects', Bridget Williams Books is delivering public service after public service. We have come so far from the attempts of certain Pākehā scholars to indigenise Pākehā-ness, to claim 'white native' status through settler colonial lineage. Pretty far, but not far enough. With sufficient circulation, and subsequent action, perhaps the current generation of Māori activist-intellectuals (and their Pākehā allies) will make irredentists and decolonisers of us all.

1. Patrick Wolfe, 'Settler Colonialism and the Elimination of the Native', *Journal of Genocide Research* 8:4 (2006), 388.

# Facing Last Things
Harry Ricketts

**The Mermaid's Purse** by Fleur Adcock (Victoria University Press, 2021), 80pp, $25

The arrival of a new collection from Fleur Adcock (her nineteenth) is a red-letter day. Here are fifty-one fresh opportunities to encounter that very distinctive voice: ironic, reflective, sometimes affectionate, sometimes teasing, still mulling over life's absurdities and their capacity to intrigue and appal. Adcock, as she puts it in 'Magnolia Seed Pods', is still 'carry[ing] on as I've always done: / picking things up and looking at them', and continuing to fix our attention with her findings.

Inevitably, perhaps, for somebody in their late eighties, one of the things she looks at most consistently here is death (although this is of course no new subject for her). 'A Small Correction' offers a wry, unsolemn elegy for the fellow-expatriate New Zealand poet Mike Doyle (1928–2016): 'Gentle, apologetic, vaguely awkward, / good-looking enough to pose in a full-page ad / for a tailoring firm'. 'Poems for Roy'—the final item—is a brilliant twelve-poem elegiac sequence for the English poet Roy Fisher (1930–2017). All the trademark Adcock qualities are on show. There is the apparently playful, increasingly disconcerting detail: death in 'Dead Poets' Society' is referred to successively

as 'mouldy old Death', Skeletonguts, Boneface and Gogglesockets. There is the sudden, flicking exactitude of phrase: a sunset is described as 'rosy-pink with pollution', a blizzard as bringing 'hypnotic light'. There is the abrupt switch to utter directness: 'His last word, I'm proud to report, was "Fuck".' There is the quiet gratitude mixed with self-ironising: 'you were always tolerant of me, / with my role-play and my little dramas'. There are the almost-but-not-quite symbolic moments. In one poem, Fisher is (or is he?) likened to his old Pyrex saucepan: 'solid, / quaint with survival from an earlier age … But oh, the glow!' There is everywhere palpable but understated feeling: 'When I allow myself to plunge / into my file of your letters'; 'I've kept this red rubber band; / it's the one I took off // the flowers from my garden … before I laid them down / on your wicker coffin'; 'I needn't think that just because you're dead / I'm absolved from my annual duty / of writing a poem for your birthday'. The more you read the sequence, the more moving it becomes and the more Adcockian it seems.

Other familiar preoccupations press their claims: children, family, friends, relationships, wildlife (a panegyric to bats: 'the dipped-wing fly-past'), wordplay, the *mot juste*, the act of writing and not forgetting a lifetime spent shuttling, literally and imaginatively, between the UK and Aotearoa New Zealand. 'Island Bay' and 'The Teacher's Wife' are the latest instalments in a gulf stream of poems that equivocally explore these divided loyalties. 'Bright specks of neverlastingness / float at me out of the blue air' opens the former, hovering on the edge of a nostalgia which the third and fourth lines inevitably check—'perhaps constructed by my retina // which these days constructs so much else'—before, for once, lyrical celebration is allowed to return: 'or by the air itself, the limpid sky, / the sea drenched in its turquoise liquors'. 'The Teacher's Wife' more intricately interweaves various semi-fictionalised long-ago reminiscences about Grahams Beach with, as the helpful note tells us, 'a wider meditation on ways in which New Zealand women, including Iris Wilkinson (the poet and novelist Robin Hyde) have been drawn to the sea or to drowning'.

The gone but not forgotten of the London literary world—and the forgotten but not gone—are wittily, if anonymously, replayed in 'The Annual Party': 'They have wheeled in the famous novelist, / the sacred monster; we thought he was dead, / after that biography …' Party naughtinesses of yesteryear are insouciantly reprised in 'The Other Christmas Poem':

> By the time Alex tiptoed upstairs
> for more wine from the stash in his study
>
> (the children, thank God, were sleeping
>    soundly)
> he was the only adult in the house
> wearing so much as his underpants.

More sombrely, 'Berries' and 'Amazing Grace' (placed next to each other) engage—subtly, persistently—with inhumanities, present and past. Behind the litany of fruit in 'Berries' we glimpse starving children in an Indonesian prison camp, 'squatting by the roadside / ... picking maggots out of a thing they've found'. 'Amazing Grace' ironically evokes the story and legacy of John Newton, the hymn's 'reformed slave trader, famous convert' author. The poem is set in St Mary Woolnoth—beneath which Newton's remains once lay before being 'translated' back to 'his old parish of Olney, Bucks'—and from the vault of St Mary someone is now 'bawling' the hymn. The concluding couplets are withering:

> His mission is to strike the shackles
> from the ankles of the City traders
>
> and other worshippers of Mammon—
> slaves to flummery, slaves to pelf.
>
> More slaves here than in Olney;
> even within earshot, slaves galore.

Adcock has always been wonderfully adept with form and prosody. (Her 1974 elegy 'In Memoriam: James K. Baxter' uses the relatively unusual Venus and Adonis stanza; in 'Stewart Island' [1971] and other poems of that time, she experiments with syllabics.) Here there are games with various adumbrated sonnet shapes. 'Sparrowhawk', a terrific poem about 'a witch from the woodlands' that 'hunch[ed] on the wind-wobbled buddleia' and terrified all the small garden birds, mimics (without rhyme) the Petrarchan sonnet's quatrain, quatrain, sestet format. By contrast, 'Novice Flyer' (about a dead young robin found 'beside the antirrhinums', 'surprisingly heavy, surprisingly warm— / just getting the knack of being dead') reverses the Petrarchan arrangement (sestet, quatrain, quatrain) with just a hint of off-rhyme. 'Letting Them Know' (about how those who live alone 'want to be found before we rot') is more elaborate. While its rhyme pattern gestures towards a reversal of the Petrarchan form, it is in couplets that simultaneously gesture towards the local Baxterian variant. The unrhymed 'Anadyomene' describes how a sometime lodger had on the spare bedroom wall 'copied studiously' the Botticelli Venus, but later 'rollered [it] over'. The poem is set out as quatrain, sestet, quatrain, the buried sonnet-traces very faintly mirroring the 'microscopic flecks / of golden paint' you might find if you were to peel off 'the layers / of emulsion'.

It might seem that detecting and admiring such 'sonnet-ghosts' is merely to point to the technical pleasures of these poems; that would be to underestimate the unobtrusive poetic craft that underwrites and is intrinsic to all Adcock's work, and which helps to make it cohere. She remains one of those poets from whom one can always learn something new, whether of organisation, tone, subject matter or treatment. She is also a poet who makes the act of writing poems seem at least possible rather than

something remote and unattainable, the product of some rarefied realm to which the rest of us could never hope to aspire.

I have left till last the remarkable title poem, 'The Mermaid's Purse', which opens the volume. This is partly because, together with the sequence of elegies for Fisher, it is the star of the show. Partly, too, because I hoped I would have a clearer idea of what to say about this enigmatic item if I wrote the rest of this review first.

I am not sure I have reached that point of clarity; however, here goes. The three six-line stanzas of 'The Mermaid's Purse', while containing plenty of Adcock wit, offer a kind of metaphor for the collection as a whole. The first stanza establishes the literalness of the mermaid's purse: 'full of squirmy sea-larvae'. (Thanks to Google, I now know that in oceanic terms mermaid's purses really exist and are 'a tough leathery pouch that protects a developing shark or skate embryo'.) But Adcock neatly complicates those literal connotations by thinking of purses in human terms: 'she doesn't carry actual money, / but then she's not an actual mermaid'.

The second stanza implicitly presents Adcock herself as a kind of mermaid: 'Three times I crossed the equator—by water ... The coloured surface is camouflage; / underneath is black; black and heaving.' The third stanza starts with the question: 'So where do we go from here?', the answer being 'Down, down, / where the eels go.' Which seems (a half-echo of Adrienne Rich's 'Diving into the Wreck'?) to affirm that poet and reader are about to undertake some shared inner exploration of the self, of the past (and, on another level, a submersion towards death?). And yet, this joint venture is seemingly immediately severed:

> Don't wait for me—
> I'll be along later. Down, down—
> think of me supping at mermaid's milk
> as you shrink into your philosophy.
> The mermaid's child will be a dogfish.

I think this means (something like) that the reader will go on ahead through the collection ('shrinking into [our] philosophy', trying, like me, to make sense of it) while the mermaid (now a kind of maternal muse figure) is replenishing Adcock.

But even if some of that is off the mark, the mermaid herself does seem to be a sort of poetic alter ego, the purse a metaphor for imagination and memory which help to gestate life's raw materials into poems. This more allegorical, phantasmagorical mode is rare in Adcock's work, though occasionally hinted at in the margins. To find it here upfront, framing this compelling new collection, is a further jolt, and delight.

# Standing Strong
Tina Shaw

**Sista, Stanap Strong!** Edited by Mikaela Nyman and Rebecca Tobo Olul-Hossen (Victoria University Press, 2021), 180pp, $30

If ever one has viewed Vanuatu as an idyllic paradise where life is easy, *Sista, Stanap Strong!* will soon dispel the myth. This anthology of writing by Vanuatu women—the first of its kind—shines a light on women's lives in the archipelago. In poems, non-fiction pieces, stories and song, themes emerge of violence towards women, a misogynistic and patriarchal society, colonialism, the importance of education, and concern for the kind of world children will one day inherit.

One of the most powerful subjects is that of blackbirding—the kidnapping of ni-Vanuatu for the purpose of slavery. From around 1847, thousands of boys and young men were tricked or coerced onto boats and taken to Australia. The opening story, 'The Bitterness of Sugar Cane' by Losana Natuman, brings this grim history to life via the story of a boy who has been kidnapped with his uncle. The boy is too young to join the kava ceremony, yet is set to work cutting sugar cane. His uncle comforts him with songs in Bislama. Meanwhile, back on Tanna Island, the effect of this kidnapping remains with the mother as she faces the horizon, the sea crashing around her ankles.

Frances C. Koya Vaka-uta's poem 'Leiniaru, the Girl from Pele Island Who Picks the Fruit of the Niaru Tree' considers the tragic story in a death certificate:

> The death certificate speaks of blackbirding. A stolen childhood.
> Whispers the fears of a child slave. They did not tell us she was so young.

Another writer who draws on history is Nicole Colmar, part ni-Vanuatu and part-Kiwi. In 'The Octagonal House', a 13-year-old girl is sent away as a bride to a white planter. With echoes of a child as commodity—taken from both her island and her family—this story is threaded with a sense of loss: 'Four years later, Eva is still standing on the pearl-coloured shores of the island.'

Coercion and violence are seen not only in historical terms but also in the contemporary treatment of women, and form a central part of the anthology. Telstar Jimmy writes of surviving a gang rape and considers the abuse that she hopes her daughters will avoid.

In 'Mared', Savianna Licht contrasts a bride who looks 'like an angel with her long trailing veil and snow-white wedding gown, with matching white Cinderella shoes' and a beaten aunt 'limping, while serving guests at one of the tables'. It's easy to see the bride's future written in the aunt's broken figure. Roselyn Qwenako Tor's poem 'Is It Real Love?' similarly shifts from a place of innocent happiness to the bonds of marriage:

The wedding ring became a noose
The wine indeed her blood
Danced to slaps and beatings
The music her mournful wailing

But staying is not always the only option. Shina Manmelin offers an antidote to the problem of a stifling relationship—'I was a slave living with this man'—in the title 'Being Single is Cool'. Manmelin writes of how another woman saved her, and of the love she holds for her children. And in 'Beatrice's Visit', Carol C. Aru tells the story of a woman who has left her husband and asks her friend Tina for money to get back on her feet. Things are tight in the household—Tina earns only a low teacher's salary and is reliant on her husband's goodwill. 'Even though he ensured his family had a good life, he never gave her extra money for her personal shopping. Tina knew Leo would say he had none and that would be it.' She may want to help her friend, but Tina's decisions are constrained within the cultural expectations of her marriage.

Although most contributions are in English, work in both Bislama and English is also included. The poems by Irene Abbock also explore the theme of difficult relationships:

Yu no kat lav
Yu no wan man
Yu no kat valiu

You don't have any love
You are not a worthy man
You have no values
('Mi Taet Finis'/'I've Had Enough')

Sharyn Wober's bilingual poems reiterate the strength that women must find. She exhorts her sisters, 'Know that you have a voice/ Know that you have a dream':

Tingbaot se yu gat wan vois
Tingbaot se yu gat wan drim
('Wan Strong Woman'/'A Strong Woman')

If male violence is on the one hand ever-present, there is also, crucially, an expression of women's empowerment. Abbock's contributor's note affirms a response that is woven throughout this collection: 'If writing a poem holds space for sexual violence activism then I am honoured to be part of it.' This theme of empowerment, and the authors' hopes that their daughters may experience something similar, finds voice in many of the works. It's an aspiration that a number of the writers, such as Pauline Chang Ryland, echo and return to:

Little girls frolicking innocently
Basking in the sunshine
What will your future be?
('Glimpses: Women from Tanna')

Ryland's poem 'WIFE—Woman in Ferocious Environments' describes the personal strength to be found within, despite the difficulties that lie in relationships:

But I will not give up
I will be the voice of reason
I will continue to love

The non-fiction pieces open a window on the lives of women and politics in

Vanuatu. Rebecca Tobo Olul-Hossen and Nellie Nipini Olul write about becoming ni-Vanuatu after independence was achieved in 1980. The country was divided along multiple lines and into many factions. 'I did not know what independence was about. Many people didn't. To us it was just an idea. Maybe a dream.' Caroline Nalo sketches a fascinating account of walking through the bush to reach isolated villages in an attempt to collect the first census in 1967 and the obstacles they encountered, such as being threatened by a 'sorcerer', and a village that had a reputation for poisoning unwelcome guests.

Meanwhile, Mary Jack Kaviamu writes of the political acceptance of women, the Tanna Women's Forum and how she came to contest the 2016 election—pitted against the notion that 'women don't belong in parliament'. Being centre stage during the campaign was challenging for Kaviamu as she was perceived to be defying 'kastom' or traditional culture. In some communities she was not allowed to campaign, and women who wanted to vote for her were intimidated with violence: 'men threatened to divorce or physically torture their wives if results showed a significant number of women's votes from that particular polling station'.

Yet Kaviamu ends on an optimistic note: 'We will continue to empower women until they can think and speak for themselves.' Indeed, much of the book, while depicting hardship, also points to more optimistic outcomes. Mildred Sope—one of the first Indigenous writers to be published before Independence—recounts how she managed to go to school: 'The eldest in my clan, my father's father, said, "You have to kill a pig before you go."' Sope was ten at the time. With this induction or challenge she was also given a special name—Molibui, meaning 'they can call you mother'.

Anna Naupa, in 'I Always Wanted to Become a Writer', talks about being introduced to Pacific literature at the University of Hawai`i. She yearns for writing that explores 'the inherent tensions in life that a young, mixed race, middle-class Melanesian woman in a modern country founded on traditional values must face'. Naupa herself has produced Vanuatu's first non-fiction book for children about inspirational ni-Vanuatu.

The varied and personal voices in this anthology offer a wealth of women's experiences exploring and expressing what it means to be ni-Vanuatu and of Vanuatu descent. As the editors point out in the Introduction, 'Beyond Vanuatu's borders readers may struggle to find any fiction or poetry by ni-Vanuatu writers.' This collection is an important step in addressing that gap.

# A Quiet Joy
Jacinta Ruru

**From the Centre: A writer's life** by Patricia Grace (Penguin, 2021), 304pp, $40

I knew I would adore this book even before I first held it. I am not an impartial reviewer. Patricia Grace has loomed large in my life since my high school English teacher first shared some of Grace's writing with us. This was my lightbulb moment growing up. It was the first time I had read Māori stories about Māori families, and they motivated me to learn more about the resilience of Māori in the face of colonisation and racism.

Grace's work has had a profound impact on my personal and professional life. Her writing has given me insight and hope, and, in turn, I have found ways to bring her work into my role as a law lecturer. Every year students begin their study of Laws 455 Māori Land Law at the University of Otago by reading Grace's short story 'Sun's Marbles'. Students, more used to reading the words of Parliament and the courts, delve headfirst into the relationships between Earth and Sky and, as described by Grace in this story, the 'Johnny-come-lately' Māui. It is a poignant way to begin learning how to prepare to work with Māori clients on their Māori land concerns.

When I first laid my hands on *From the Centre: A writer's life*, I was filled with quiet joy. Here was a master at work. Grace provides a generous insight into her life, and in doing so provides us all with a rare accessible glimpse of being Māori in Aotearoa.

Chapter one is a fine example of a superbly skilled weaving of time, observation and family. She begins with the lounge where she is sitting and what she can see from there. She describes the pūriri tree and the birds who are visiting: 'Three tūī were here this morning, on overdrive, leaping about and feeding, flying out and back, out and back before leaving altogether.' I am immediately comfortable, thinking of my parents who fuss over their backyard birds. But Grace does not pause there for long. Her gaze enlarges. She's sitting in the house she built with her husband Dick in Hongoeka Bay more than forty years ago. In just a few sparse pages, she shares with us the memories of Kupe crossing the Pacific Ocean to name the lands she sees, the ramifications of the 1840s onwards when colonial governments sought 'to better facilitate Crown pickings' of Māori land, and how today her whānau 'have found it necessary to make an application to the High Court to have [their] rights re-recognised'. Despite this law, she writes: 'life goes on … we fish, we gather pāua and kina, and though crayfish are not as plentiful as they once were, we enjoy these once in a while'. And so her memoirs begin.

The twenty-seven short chapters are chronological. Chapter two begins with the day Grace was born and on which the All Blacks played the Springboks, and is

mostly devoted to her maternal grandparents. The chapter ends with remarks about her problematic relationship with her grandfather, how her affection for him 'lessened as I grew and came to realise his deep prejudices'. Her strategy—'to treat him with some respect (and some avoidance)'—demonstrates the honesty and humanity that are on full display from start to finish of this precious book.

*From the Centre* weaves the span of Grace's life to date interlaced with snippets from her published fiction and non-fiction. It is a treat to gain further context for where and how her stories were born. A quote from her 2004 novel *Tu* frames chapter five, which is devoted to the story of her father, who joined the volunteers of the 28th (Māori) Battalion even though he knew going to war 'meant leaving work, which would likely not be available for him on his return'. During teachers' college term holidays, Grace worked at the Olympic Stationery factory that features in her 1992 novel *Cousins*: 'Her first job at the factory was to wrap bundles of exercise books in brown wrapping, which she gummed down with strips of sticky paper.' With regard to *Chappy* (published in 2015), she describes the challenge of writing about a man from Japan: 'I was determined that I would not go with perceived stereotypes. I did not attempt to enter the psyche of a Japanese man but sought to understand his heart as a human being.'

As I read of her fondness for school and sports, of falling in love and starting a family and career, I hoped she would mention my all-time favourite book by any author, *Baby No-eyes*, published in 1998. I was in luck. Chapter twenty-four is initially devoted to 'a horror story' that she could not get out of her mind. It's the tale of a whānau who sought to know why their stillborn baby's eyes had been removed. Grace based her story on an event that happened in 1991 which was, as she says, 'hardly the dark ages'.

From a young age, Grace closely observed injustice and inequity and found dignified ways to make change. In this book we gain appreciation for her experiences of growing up and, for example, of finding out that she was a Māori girl and how, therefore, 'being different meant that I could be blamed'. But these experiences, she notes, never 'loomed large in my life'. Here she credits her family for their support. In her ever-so-practical approach she writes, 'These are matters I learned to deal with.'

But what 'dogged' and annoyed her throughout her schooling was the frequent low expectation of her as a scholar. These are truths that need to be spoken about in order to disrupt such prejudice continuing in our education system. Grace notes: 'I was continuously having to prove myself. In some ways this was good for me. It made me strive, always needing to have high marks, excellent reports, neat books and handwriting. But at a certain stage of my education this all caught up with me.' In a later chapter she writes:

Up until that year, I had never known a bad report. Now they were coming in at the end of each term: I wasn't working, wasn't trying … Comments from teachers indicated that I would be unlikely to pass School Certificate … My parents must have been puzzled by these reports, because they'd seen me at my books, night after night. They told me that they knew I was doing my best, even though I knew I wasn't and didn't understand why I couldn't. But I believe it was the support my parents gave me, had always given me, that got me through that time.

Grace's curiosity and observation were, thankfully, never dampened. In chapter fifteen she writes about her own lightbulb moment on reading Frank Sargeson's short story collection *A Man and His Wife* (1940). Until then, Grace hadn't realised 'that daily life, everyday speech, contemporary New Zealand family relationships could be made into stories'. She began to focus her own attention on stories about 'everyday people': 'What people around me do and how they do it, what they say and how they say it are of enormous interest.'

Grace has certainly carved out a writing style that brings alive the families, communities and coastlines of this place, Aotearoa New Zealand. Her seven novels, the first being *Mutuwhenua: The moon sleeps* in 1978, seven collections of short stories, three non-fiction books and several children's books are filled with her wit. Her intelligent seeing gaze and command of the written word enables readers to emotionally connect with and remember her stories. *From the Centre* can and should be considered an instrumental companion to be read alongside her lifetime of work.

It was interesting to read about her vision, in 1981, for her first children's book to be published in both English and Māori, *The Kuia and the Spider*. She writes: 'I knew of nothing else of the kind, but the publishers were not enthusiastic.' She persevered and found a willing publisher who would, from there on, produce all her children's books in both languages. She found allies who 'pushed forward, with the understanding that every child needed to see her or his cultural values and images reflected in literature'. It would be a wonderful testament to her literary legacy if all her adult books were likewise translated into te reo Māori.

I hope too that this book, and all of Grace's work, becomes a proud central pillar of the English school curriculum in Aotearoa New Zealand. Her stories jolt us into realising there is another way to see the world, to understand the world—and that this te ao Māori perspective is important for us all to see, hear and feel as we deepen our sense of who we are as a country in the South Pacific.

There are too few published Māori autobiographies. This memoir shows us the enormous value of canvassing one's life for all to read, and why we need more Māori to write about their lives. The gentle weight of this beautiful work, in both a physical and emotional sense, will live with me for a long time. This was always going to be a special book for me. I hope it becomes a treasured read for all New Zealanders, young and old.

# What a Human Muddle
Stephen Stratford

**Life as a Novel: A biography of Maurice Shadbolt, Volume 2 1973–2004** by Philip Temple (David Ling Publishing Limited, 2021), 352pp, $44.99

Another marvellous performance from Philip Temple with multiple plots and time-lines expertly interwoven. As with Volume 1, it is a triumph of research and narrative skill. But what is missing is a subtitle. Perhaps this quote from Shadbolt: 'What a human muddle I leave in my wake.'

God, this book is grim reading. Not the author's fault—it is entirely the subject's. There are many upsetting passages but none more so than when Shadbolt's daughter Tui came up from Wellington by train, on her own, and he refused to see her. She was twelve.

Volume 1 seemed at times a bonk-buster, and Volume 2 does not disappoint in this regard. At the launch of *A Touch of Clay*, Temple tells us, a young English lecturer asked Shadbolt 'how he was feeling. "Lonely," he said.' It worked: 'The young lecturer, one of several moths to the flame, attended to his loneliness over the days following the launch.'

At one point in London Shadbolt was entangled with three women, none of whom seemed to know the other relationships were going on. When he was with Fleur Adcock she told him he 'was a shit' after he made advances to Bridget Armstrong. His engagement to Armstrong was news to his then partner, who 'was devastated' when the *Herald* reported it. When he was married to Armstrong, they went to spend the weekend with 'actor Bruce Purchase and his wife, Elspeth Sandys', and my heart sank because I knew what was coming:

> [H]e began to make up to her while Purchase and Bridget were drinking hard together in another room ... Maurice followed this encounter by writing romantic overtures to Sandys until she told him to stop.

After Armstrong had left the marriage and was living again in London, Shadbolt went to Europe on *Reader's Digest* assignments and let himself into Armstrong's house, 'causing her shock and fury when he opened the door on her return home'. Her friend Caroline Ireland threatened to go round with an axe if he came back. (She would have, too.)

After Armstrong was out forever, Shadbolt wrote to Sandys: 'I fell in love with you years ago ... The other women, the wives, they were all substitutes for you.' Temple, who has an excellent bullshit-detector, comments: 'Successfully capturing a new wife was like resolving the structural problems of a novel. Could he make it work? Could he sell it?' At the same time, Shadbolt was writing to and phoning ex-lover Beverley Bergen. It all seems a bit pathetic, this inability to live without a woman in the house ('I am frighteningly dependent on females').

Later, when Shadbolt had successfully captured Sandys and she wanted to spend half the year in England, where her career was, Temple notes his protest: 'But you must be with me.' Temple adds drily that after writing the first 150,000 words of *The Lovelock Version* 'he had to take a break, it was time to get married again'. Early on,

> To his closest male friends he would boast about his endless conquests, claiming that the difference between an ordinary fornicator and him was that he made women fall in love with him … It had become an addiction to seduction.

I found all these bad-behaviour stories very lowering. Fortunately, there is much more to the book than this gossipy who's-had-who stuff. The wider cultural context makes the book as much a social history as a life of a writer. There is the baleful long-term effect of cost overruns of the television series *The Governor*, PM Robert Muldoon's subsequent refusal to raise the licence fee and the knock-on effect of that on Ian Cross's vision for TV One and TV Two (we are still suffering the consequences); how that 'sounded the death knell for serious drama', including the projected television adaptation of Shadbolt's novel *Strangers and Journeys*, which was a major financial blow; and the sheer amount of work that goes into making a TV documentary.

Temple is outstanding on the business side of the writing life. He is a good guide to the Authors' Fund since he knows as much about it as anyone, and how precarious it was in the early days—it was subject to the iron whims of Muldoon. There are sales figures; inventories of publishers' and booksellers' stock; how Shadbolt's *Shell Guide* was not selling because of Diana and Jeremy Pope's rival *Mobil Guide* (well, theirs was much better); and fees from *Reader's Digest* articles and books. The money is astonishing: Shadbolt received $65,000 for the text for the 1988 *Reader's Digest Guide to New Zealand* (which is many times what I was paid for the 1998 edition). In 1984 he wrote 9000 words about the Erebus Inquiry for *Reader's Digest* ($8000) and a script for a Gallipoli doco ($12,000); he also sold the film rights to *Among the Cinders* ($2000 or so). These are all in 1984 dollars.

'Money rolls in, but what for?' he wrote then. 'Unless to keep me going as a novelist, there's no sense.' There's no pleasing some people.

Journalism wasn't just useful for the money: 'In that age of post-Pill and pre-AIDS he could look forward to frequent amatory encounters as he travelled Europe for *Reader's Digest*, all expenses paid.' Yet despite these apparent successes, there are many phrases in this account along the lines of 'tumultuous personal life', 'Maurice's equilibrium was fragile', 'the recurrent chaos of his domestic life', 'a refuge from the slowly collapsing domestic environment beyond his bush studio'. Did I mention that this was grim reading? But Temple is remarkably non-judgmental: he describes one journal entry as 'almost

histrionic self-pity', the kindest use of 'almost' I have seen.

Meanwhile, Shadbolt's drama was not only with women and matters of money. In a rehearsal for the play *Once on Chunuk Bair*, director Ian Mune wanted cuts. Mune later wrote, Temple tells us: 'If challenged, [Maurice] will explain in excruciating detail why every word was essential.' In the Shadbolt version: 'Ian and I had marvellous rapport in cutting.' It was the same with the Gallipoli television documentary where, Chris Pugsley says, they would debate a word for 'what seemed like hours'. Shadbolt seems to have been writing for the page, not the stage; actors and directors saw scripts as words that were to be spoken—they *had* to work that way. Very different propositions.

Then there are the mental health issues. There is a lot of depression but also a fair bit of what seems its flipside: mania. Each new relationship/marriage is, at last, *the one*. Here, Temple captures Shadbolt's giddiness at new love: 'The marvellous thing about B[ridget] is that I can talk to her about my work—the first time this has truly been so.' To which I would respond: 'Bollocks.' Armstrong is as sharp as anyone I know, but he had already had relationships with Marilyn Duckworth and Fleur Adcock, both of whom know quite a bit about writing.

Temple also deftly tackles Shadbolt's verdicts on his books: 'As usual he thought [*The Lovelock Version*] was by far the best thing he had written.' He quotes Shadbolt himself: '[I]t should be magnificent—something the like of which literature has never seen.' And: 'I make bold to say that no one has written a novel like it.' Temple points out the heavy influence of Marquez's *One Hundred Years of Solitude*, but concedes it was something new in Australasian fiction. As for *Season of the Jew*, it was 'ready to walk out into the world and what a book! No one can take this triumph from me.'

Ah yes, *Season of the Jew*. As Temple lays out, *When the War is Over* by Shadbolt's American friend Stephen Becker was a model for it; unforgivably, Shadbolt did not acknowledge this. When he and Armstrong visited Becker, she started reading the American novel and 'soon exclaimed to Maurice, "It's exactly the same as *Season of the Jew*. It's exactly the same book. The same language!" He grabbed the book and said, "Don't you dare mention it, don't you dare!"'

There is an injection of fizz whenever Temple quotes Armstrong. One can hear her marvellous voice—she is our own Joan Greenwood. Take, for example, this moment, when she

> recounts that, on the 'plane from London, Maurice asked about her taste in music and, when she hesitated, told her, 'Well I only like Mahler and Sibelius.' 'Oh Christ,' she thought.

At times Shadbolt's notorious hypochondria looks suspiciously like dodging his financial obligations. He was slippery with money, especially with his *Reader's Digest* commissions: 'The magazine met the costs of intra-European travel. To magnify his income,

he claimed those European expenses against income in his tax returns; but kept the *Digest* expense payments in a separate bank account and did not declare them.'

When Shadbolt pleaded poverty, Temple records his net income for that year as $87,000, which put him 'in the top five per cent of all income earners'.

Then there is the weird relationship with Michael King, who as a hustling freelance historian tried to get in on Shadbolt's book of the television documentary about Gallipoli. There are four major spats. The first was over King's *Listener* review of *A Touch of Clay*, which Temple sees as 'a thorough and fair review, but brutally honest'. Next, King objected to Shadbolt's version of Lt-Col William Malone in *The Lovelock Version* and wrote a negative review for *Metro* of *Voices of Gallipoli*. Then, Shadbolt assumed that King wrote a 'wretched little paragraph' critical of him in *Metro*'s 'Felicity Ferret' column. He didn't—I did—but the information in it came from King, who was adept at lobbing hand grenades and being some distance away whistling innocently when they exploded.

The worst spat was when King got the page proofs to review *One of Ben's* for *Metro* and showed CK Stead the page where Shadbolt described him as 'elderly, bitter and bald' (Stead was sixty). Temple says, quite rightly, 'King's action was utterly unethical; especially since he had already told [publisher David] Ling the phrase might be inflammatory and he and Maurice decided to remove it. King was not invited to the launch.'

King's subsequent *Landfall* review of *One of Ben's* quoted the passage deleted from the book. I don't know of a shabbier episode in our literary life.

For my taste there is a bit much showing of the author's political views. There is a snark about Muldoon winning an FPP election he wouldn't have under MMP (voting systems are an enthusiasm of the author's); the destruction of an Auckland theatre is blamed on Roger Douglas when it was under Labour mayor Cath Tizard; and an endnote to a paragraph about academics disparaging professional writers says, 'More recently, writers who wish to enter the halls of literary recognition should complete a degree in creative writing from an approved institution.' Still, in a seven-year project an author may be forgiven the occasional tiny indulgence.

The Epilogue is a superb summary of Shadbolt's oeuvre—the fiction, nonfiction, journalism, drama, TV docos, the lot. The bibliography is as much information as one would want; discussions of the novels that occur throughout this volume are as illuminating as one would expect from a writer and reader as thoughtful as Temple. Publisher David Ling's contribution must be applauded too, not least his provision, as in Volume 1, of an exemplary index by Diane Lowther.

This is often an awful story, but it is an outstanding book.

**Scorpio Books**

are delighted to introduce you to...

# Telling TALES

### Scorpio Children's Books

A dedicated children's book shop in the heart of Christchurch – visit us today!

**Telling Tales
Five Lanes – BNZ Centre
tellingtales@scorpiobooks.co.nz
Phone: 03 741 3309**

# New from Victoria University Press

$35

$35

$30

$50

# UNITY BOOKS

57 Willis Street, Wellington | 19 High Street, Auckland
unitybookswellington.co.nz | unitybooksauckland.co.nz

# NEW BOOKS FROM
# OTAGO

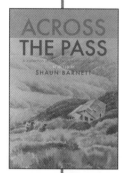

**ACROSS THE PASS:** A COLLECTION OF NEW ZEALAND TRAMPING WRITING

SELECTED BY SHAUN BARNETT

Across the Pass *includes writing from New Zealanders such as trampers Mark Pickering and Geoff Spearpoint, writers John Mulgan, David Hill and Elsie Locke, mountaineer Sir Edmund Hillary, adventurer Graeme Dingle, journalist Elsie K. Morton, and poets Blanche Baughan, Sam Hunt and Brian Turner. All say something about the experience we call tramping.*

ISBN 9781990048081, hardback, $45

**WAI PASIFIKA:** INDIGENOUS WAYS IN A CHANGING CLIMATE

DAVID YOUNG

*In this beautifully written and stunningly illustrated book, David Young focuses on the increasingly endangered resource of freshwater and what so-called developed societies can learn from the Indigenous voices of the Pacific.*

ISBN 9781990048074, paperback, $60

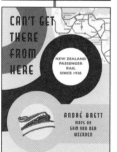

**CAN'T GET THERE FROM HERE:** NEW ZEALAND PASSENGER RAIL SINCE 1920

ANDRÉ BRETT & SAM VAN DER WEERDEN

*In this fascinating study, Andre Brett argues that the trend away from passenger rail might have appeared inevitable and irreversible but it was not. Things could have been – and still could be – very different. Includes more than 100 superb colour maps.*

ISBN 9781990048098, paperback, $65

**TUMBLE**

JOANNA PRESTON

*Joanna Preston's bold and original voice swoops the reader from the ocean depths to the roof of the world, from nascent saints, Viking raids and fallen angels to talking cameras and an astronaut in space. This beautifully crafted collection traverses the lyric, free verse and traditional forms. It's earthy and embodied while at the same time woven through with myth and magical realism.*

ISBN 9781990048197, paperback, $27.50

# OTAGO UNIVERSITY PRESS
*From good booksellers or www.otago.ac.nz/press*

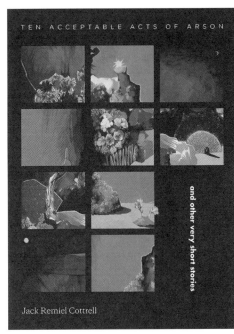

## TEN ACCEPTABLE ACTS OF ARSON
### and other very short stories
JACK REMIEL COTTRELL
$29.99, pb, 136pp

These finely-tuned flash fictions traverse sci-fi, fantasy, comedy, horror, romance, and hybrids of all of these.

"Its delights, of which there are many, will be best sampled and savoured a few at a time."
*North & South*

"Fiercely intelligent, poignant and endlessly surprising" **Frankie McMillan**

**Canterbury University Press**
www.canterbury.ac.nz/engage/cup

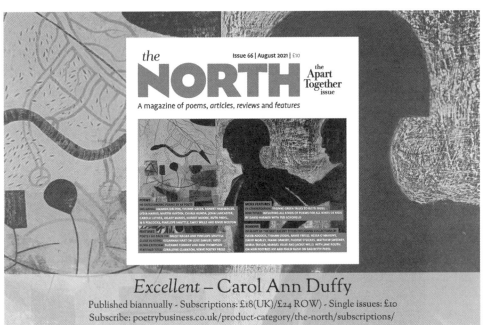

*Excellent* – Carol Ann Duffy

Published biannually - Subscriptions: £18(UK)/£24 ROW) - Single issues: £10
Subscribe: poetrybusiness.co.uk/product-category/the-north/subscriptions/

## New and established poets ~ HeadworX New Poetry
http://headworx.co.nz

*Slips: Cricket Poems* (pb, hb) by Mark Pirie
*Selected Poems* (pb, hb) by Margaret Jeune
*Meditations* (pb, eBook) by Alex Jeune
*The Narrator* (pb) by Jeanne Bernhardt

In selected bookstores or direct from the publisher

### HeadworX
*Publishers*

---

**TE PUNI KAITUHI**
O AOTEAROA
THE NEW ZEALAND SOCIETY OF
AUTHORS (PEN NZ INC)

**Working for writers since 1934:**

Protecting rights to freedom of expression
Working to improve income and conditions
Copyright protection and legal advocacy
Manuscript assessment and
  mentoring programmes
Literary awards and prizes
Developing and promoting
  New Zealand writing
Regional branch network and writing hubs

*Join our community of writers*
**authors.org.nz**

---

## Charles Brasch Young Writers' Essay Competition 2022

**PRIZE: $500 + A YEAR'S SUBSCRIPTION TO LANDFALL**

**JUDGE: LYNLEY EDMEADES**

**ENTRIES CLOSE 31 MARCH 2022**

**Entry details at**
https://www.otago.ac.nz/press/landfall/awards/otago0625789.html

 OTAGO UNIVERSITY PRESS

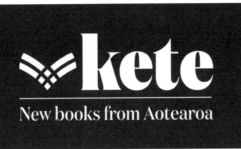

Browse new books and independent reviews.
Subscribe for weekly bestseller lists,
reviews and giveaways.

**ketebooks.co.nz**

Join The Coalition for Books – let's love local – coalitionforbooks.nz

*University Book Shop... Your UBS*

Visit us in our new (temporary) location
Otago Museum Reserve, 361 Great King Street

*Dunedin's Finest Book Shop*

M–F  9am–5.30pm  |  Sat & Sun 10am-4pm  |  unibooks.co.nz  |  03 477 6976

## CONTRIBUTORS

**Ruth Arnison** was the editor of *Poems in the Waiting Room* (NZ) for 13 years, and is the instigator of Lilliput Libraries. In 2018 she was awarded the QSM for services to poetry and literature.

**Wanda Barker's** poems and flash fiction have been published in *Mayhem*, *Meniscus*, *A Fine Line* and *Landfall*. Her poem novella *All her dark pretty thoughts* appeared in 2017.

**Owen Bullock** has published poetry, haiku, tanka and fiction—most recently, *Uma rocha enorme que anda à roda* (A big rock that turns around), translations of tanka into Portuguese by Francisco Carvalho (Temas Originais, 2021); *Summer Haiku* (2019); and *Work & Play* (2017). He teaches creative writing at the University of Canberra.

**Nathaniel Calhoun** writes from the subtropical Far North of Aotearoa. His projects focus on monitoring and protecting biodiversity.

**Medb Charleton** is originally from Ireland. Her poetry explores the nature of experience and environment.

**Joanna Cho** completed her MA in creative writing at the IIML in 2020 and received the Biggs Family Prize in Poetry. Her writing has been published widely across Aotearoa and she is the 2022 summer writer in residence at the Robert Lord Cottage. *People Person* is forthcoming from Victoria University Press.

**Conor Clarke** (Kāi Tahu, Irish, Welsh) is an artist, MFA candidate and lecturer in photography at Ilam School of Fine Arts in Ōtautahi Christchurch. She is currently creating new work that will be part of *Paemanu: Tauraka Toi—A Landing Place*, opening at Dunedin Public Art Gallery in December 2021.

**Olly Clifton** completed an MA in creative writing at the IIML in 2020 and co-edited *Turbine|Kapohau* magazine. In 2021 he got a job pouring beer in Tāmaki Makaurau.

**Diane Comer**'s work has appeared in *AGNI*, *The Georgia Review*, *Fourth Genre* and other literary journals in the US. She has received both national and state grants for her creative non-fiction and her book *The Braided River* was published by Otago University Press in 2019.

**Ruth Corkill** is a poet from Aotearoa and a graduate of the Iowa Writers' Workshop MFA programme. Her work has appeared in *The Feminist Wire*, *Landfall*, *New Zealand Listener*, *Poetry New Zealand*, *New Welsh Review*, *Wasafiri* and *The Moth*. She is currently pursuing a PhD in physics at the University of Stuttgart and was part of an MLA International Symposium panel on contemporary physics poetry.

**Molly Crighton** is a student of English at the University of Otago. Her work can be found in *Starling*, *takahē*, *a fine line*, *The Cormorant* and *Re-Draft*.

**Andrew Dean** is a lecturer in writing and literature at Deakin University in Victoria,

Australia. His first academic book, *Metafiction and the Postwar Novel*, was published by Oxford University Press in 2021.

**Mark Edgecombe** lives in Tawa with Sarah and their three children and teaches English at Tawa College.

**David Eggleton** is a writer and poet based in Ōtepoti Dunedin. His most recent collection of poems is *The Wilder Years: Selected poems* (Otago University Press, 2021). He is currently working on a new collection of poetry.

**Emma Gattey** is a writer and critic from Ōtautahi. She is working on a PhD in New Zealand history at the University of Cambridge, and is a research fellow for Te Takarangi at the University of Otago Faculty of Law.

**Summer Gooding** is a queer Kiwi creative living in Melbourne. Her poetry is anchored by a deep connection to the natural world and an adoration for the beauty in the mundane. She occasionally writes film and television reviews, and spends her working week at a local museum.

**Isabel Haarhaus** is a writer and teacher and lives in Auckland. She has published short stories, essays, art writing and poetry and is currently working on a novella.

**Michael Hall** lives in Dunedin. Recent poems of his have appeared in *Milly Magazine*, *Queens Quarterly: A Canadian review* and *Tarot: An Aotearoa poetry journal*.

**Trevor Hayes** lives in Punakaiki. He has had poems published in *JAAM*, *Sport*, *Landfall*, *Poetry New Zealand* and *takahē*. His chapbook, *Two Lagoons*, was published by Seraph Press in 2017.

**Bronte Heron** (she/her) is a poet and library assistant living in Te Whanganui-a-Tara, where she is studying towards an MA in creative writing at the IIML.

**Jenna Heller** lives near the sea in Ōtautahi. She is a teacher at Write On School for Young Writers and is currently working on an experimental young adult novel.

**Hayley Rata Heyes** is a Pākehā poet and painter based in Ōtepoti Dunedin.

**Zoë Higgins** is a writer and performer of Swiss and British descent. She grew up on Horomaka Banks Peninsula and now lives in Te Whanganui-a-Tara. Her work has been published in *Sport*, *Starling*, *Mayhem*, *Landfall* and *Aotearotica*. She is currently working on a music-and-puppetry project called *The Veiled Isle* alongside Wellington band Birdfeeder.

**Lily Holloway** (she/they) has a Teletubby tattoo, a chapbook in *AUP New Poets 8*, and you can find a full list of her published and forthcoming writing at lilyholloway.co.nz.

**Bree Huntley** lives in Auckland, where she writes fiction and poetry and works part-time as a lawyer.

**Eileen Kennedy** lives in Tāmaki Makaurau in a flat with 22 people. She

has degrees in law and philosophy and is training to be a secondary school teacher.

**Erik Kennedy** is the author of *There's No Place Like the Internet in Springtime* (Victoria University Press, 2018) and co-editor of an anthology of climate change poetry from Aotearoa New Zealand due out in 2022 from Auckland University Press.

**Megan Kitching** lives in Ōtepoti Dunedin. Her poetry has appeared in *The Frogmore Papers* (UK), *Otago Daily Times*, *takahē*, *Landfall* and *Poetry New Zealand Yearbook*.

**Wes Lee** lives in Wellington. Her latest poetry collection is *By the Lapels* (Steele Roberts, 2019). Her work has appeared in *Best New Zealand Poems*, *Westerly*, *Poetry London*, *New Zealand Listener* and *Australian Poetry Journal*, among others. She was awarded the *Poetry New Zealand* Poetry Prize in 2019, and shortlisted for the inaugural NZSA Laura Solomon Cuba Press Prize in 2021. She will be featured poet in the *Poetry New Zealand Yearbook* 2022.

**Mary Macpherson** is a photographer, photobook publisher and poet from Pōneke. She is reviews editor for the PhotoForum website, and a member of the Photobook/NZ committee.

**Vana Manasiadis** is a Greek-New Zealand writer born in Te Whanganui-a-Tara and now based in Tāmaki Makaurau after many years living in Kirihi Greece. She is the 2021 Ursula Bethell Writer in Residence at Te Whare Wānanga o Waitaha Canterbury University. Her most recent book is *The Grief Almanac: A sequel* (Seraph Press, 2019).

**Frankie McMillan** is a poet and short fiction writer. Her latest book of fiction is *The Father of Octopus Wrestling and other small fictions* (Canterbury University Press, 2019).

**Cilla McQueen** is a poet and artist who has lived in Motupōhue Bluff since 1996. She has published 15 collections of her work and was the New Zealand Poet Laureate 2009–11. In 2010 she was awarded the Prime Minister's Prize for Literary Achievement in Poetry. Her most recent book is *Poeta: New and selected poems* (Otago University Press, 2018).

**Scott Menzies**' work includes journalism, reviews, op-ed pieces, letters and the editorship of a weekly magazine. His fiction has appeared in *takahē*, *The Commuting Book* and *Persephone's Daughters*. He is writing a story collection and a novel.

**Rebecca Nash** is a poet, lecturer and mum who lives in Lyttelton. She has an MA in creative writing from the IIML and an MA on Samuel Beckett from the University of Canterbury. Her poems have appeared in *takahē*, *Minarets*, *Turbine* and *The Spinoff*, and her book for children, *Wilbur's Walk*, is due in 2021 from Mary Egan Publishing.

**Janet Newman** has a PhD from Massey University for her thesis 'Imagining Ecologies: Traditions of ecopoetry in

Aotearoa New Zealand'. Her poetry collection *Unseasoned Campaigner* was published this year by Otago University Press.

**Airana Ngarewa** (Ngāti Ruanui) was born and raised in Pātea. His work has appeared in *The Spinoff*, *Newsroom*, *Mayhem*, *Turbine*, *Headland*, *takahē*, *Huia Short Stories* and elsewhere.

**Melody Nixon** is a writer, artist and scholar from the Far North of New Zealand. She holds an MFA in creative writing from Columbia University, where she teaches creative non-fiction.

**Claire Orchard**'s work has appeared in various journals and anthologies. Her first poetry collection, *Cold Water Cure*, was published by Victoria University Press in 2016.

**James Pasley** is a writer from Auckland. He has an MA from the IIML, and his fiction and writing have appeared in *takahē*, *Turbine*, *The Spinoff*, *Vice*, the *Sunday Star Times* and *Business Insider*.

**Robyn Maree Pickens**' poetry has appeared in the *Brotherton Poetry Prize Anthology* (Carcanet Press, 2020) and in *Fractured Ecologies* (EyeCorner Press, 2020).

**Fergus Porteous** is recently divorced and living with his parents in New Plymouth.

**Hayden Pyke** is from the Waikato and often says he writes at night when his real life is asleep. No one has yet been able to prove he has this 'real life', and it's possible he just writes the odd poem and eats cheese toasties.

**Anna Reed** is from Otago and lives in Wellington. When not wrangling young children or working on her Master of Health, she writes about pain, trauma and motherhood. Her work has appeared in *Landfall*, *The Spinoff*, *REM*, *Cordite* and *takahē*.

**Harry Ricketts** teaches English literature and creative writing at Victoria University of Wellington Te Herenga Waka. His *Selected Poems* recently appeared from Victoria University Press.

**J.D. Robertson** lives in a little-ish house on a sort of prairie, but it'll do. He enjoys watching the hawks and herons and experimenting in the greenhouse.

**Jacinta Ruru** FRSNZ (Raukawa, Ngāti Ranginui) is a professor of law at the University of Otago, where she holds an inaugural University Sesquicentennial Distinguished Chair. She holds national awards for research and teaching, and has published extensively on Indigenous peoples' rights, interests and responsibilities to own and care for lands and waters. She is the lead curator of the Te Takarangi 150 Māori Books project.

**Derek Schulz** is a Kiwi poet, essayist and writer of fictions. His collections of poetry include *Orphic Light*, *The Last Great Mystery*, *Borderlands* and *Derek Schulz: Selected shorter poems*. He received the 2018 Caselberg Prize, and was runner up in 2019 and highly commended in 2021. His

essays have appeared in *Strong Words* (Otago University Press), *Poetry New Zealand* and *The Spinoff*.

**Tina Shaw** is a novelist and editor based outside Taupō. Her latest work is *Ephemera* (Cloud Ink Press, 2020).

**Antonia Smith** is studying law and history at Victoria University. She has been writing in her spare time since she was little and has had work included in national and international publications.

**Elizabeth Smither**'s latest collection of stories, *The Piano Girls*, was published by Quentin Wilson Publishing in 2021. A new collection of poems, *My American Chair*, will appear in 2022.

**Zina Swanson**'s work employs pre-existing scientific and natural histories in order to interrogate our relationship to the environment. Her practice encompasses both painting and sculpture. She has exhibited extensively with solo and group presentations at most of New Zealand's top galleries and museums. These include the Christchurch Art Gallery, Dunedin Public Art Gallery, City Gallery Wellington and Artspace Aotearoa. Her works are also held in the collections of the Wallace Arts Trust, Christchurch Art Gallery, Dunedin Public Art Gallery, Hocken Collections and The Dowse Art Museum. Swanson has been the recipient of the prestigious Frances Hodgkins Fellowship, and in 2014 was an apexart New York Inbound Resident.

**Nicola Thorstensen** is a Dunedin-based poet and creative writing student. She is a member of the Octagon Poetry Collective, which organises monthly poetry readings. Her work recently appeared in *Cumulus*, an exhibition that featured the work of local poets alongside photographs by Carlos Biggemann.

**Richard von Sturmer** was born on Auckland's North Shore in 1957. His recent books are the acclaimed memoir *This Explains Everything* (Atuanui Press, 2016) and *Postcard Stories* (Titus Books, 2019). In 2020 he was the University of Waikato's Writer in Residence.

**Justine Whitfield** comes from Porirua. She is a graduate of the IIML and her writing has appeared in *Pantograph Punch*, *Headland*, *Turbine*, *Kiss Me Hardy*, *Strong Words 2019* (Otago University Press) and on Radio New Zealand.

**Sophia Wilson** has recent writing in various journals and anthologies. In 2020/21 her poetry sequence on migration and belonging was runner-up in the Kathleen Grattan Prize, and she was winner of the Robert Burns Poetry Competition and the Hippocrates Prize.

**Sarah Natalie Webster** is a poet and essayist from Tāmaki Makaurau. Her writing has appeared in journals and magazines in Aotearoa and the US. She is currently working on her first collection of creative non-fiction.

**E Wen Wong** is in her first year of studies at the University of Canterbury. E Wen's work has recently appeared in *A Clear Dawn* (Auckland University Press, 2021), *Ko Aotearoa Tātou* (Otago University Press, 2020) and *Poetry New Zealand Yearbook*.

**Sebastien Woolf** (a.k.a. Todd Stewart) is an author, screenwriter and poet with a Master of Professional Writing from the University of Waikato.

**Nicholas Wright** lectures in the English Department at the University of Canterbury. He recently had a poem published in *The Spinoff*. He is writing a collection of essays on contemporary poetry in Aotearoa.

**et al.** lives and works in uncertain times in Tāmaki Makaurau.

## CONTRIBUTIONS

*Landfall* publishes original poems, essays, short stories, excerpts from works of fiction and non-fiction in progress, reviews, articles on the arts, and portfolios by artists. Submissions must be emailed to landfall@otago.ac.nz with 'Landfall submission' in the subject line.

Visit our website www.otago.ac.nz/press/landfall/index.html for further information.

## SUBSCRIPTIONS

*Landfall* is published in May and November. The subscription rates for 2021 (two issues) are: New Zealand $55 (including GST); Australia $NZ65; rest of the world $NZ70. Sustaining subscriptions help to support New Zealand's longest running journal of arts and letters, and the writers and artists it showcases. These are in two categories: Friend: between $NZ75 and $NZ125 per year. Patron: $NZ250 and above.

Send subscriptions to Otago University Press, PO Box 56, Dunedin, New Zealand. For enquiries, email landfall@otago.ac.nz or call 64 3 479 8807.

Print ISBN: 978-1-99-004811-1
ePDF ISBN: 978-1-99-004821-0
ISSN 00–23–7930

Copyright © Otago University Press 2021

Published by Otago University Press, 533 Castle Street, Dunedin, New Zealand.

Typeset by Otago University Press. Printed in New Zealand by Caxton.

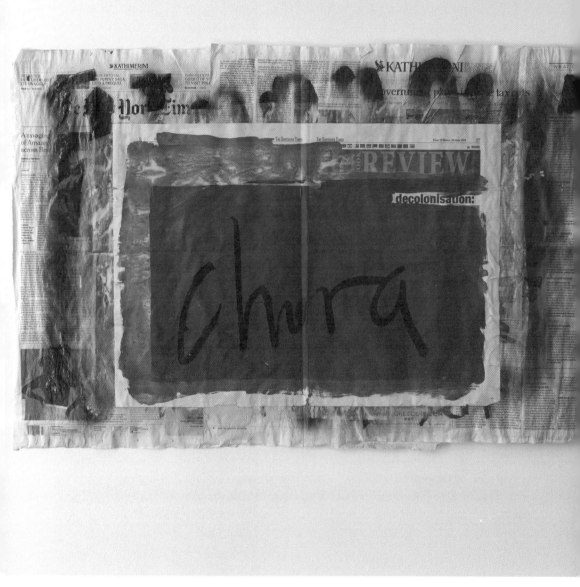

et al., *Untitled (The Southern Times, Friday 29–04 April 2019, on Kathimerini, Monday, August 26 2019)*, 2019–21, mixed media double-page spread. Photograph: Michelle Wang